L :
A Return
to Painting

Catherine McGrew Jaime

Battle Painting on the front cover is Peter Paul Rubens' copy of Leonardo's *Battle of Anghiari.*

Other Historical Fiction by Catherine Jaime:

Leonardo the Florentine
Leonardo: Masterpieces in Milan
Leonardo: To Mantua and Beyond
Leonardo: A Return to Florence

Failure in Philadelphia?
(the Constitution Convention)
York Proceeded On (the Lewis & Clark Expedition)
The Gracie Jones Chronicles: Visiting the Vanderbilts
The Attack Trilogy

Copyright © 2017 by Catherine McGrew Jaime
Madison, AL, USA

www.CatherineJaime.com

Chapter One

Assisi

January 1503

Leonardo stood silently in front of Borgia's small table, wondering what the young man had in mind this time. He had been in this small dark room before, but never at this time of day. He noticed the candle in the middle of the table had not yet been lit, but as the shadows lengthened around him, Leonardo knew it was just a matter of time.

As he stood waiting Leonardo pondered what others who had stood in this very spot must have felt. He was certain that many, if not most, had shook as they anticipated the words or actions of the ruthless and often unpredictable Cesare Borgia.

Leonardo shrugged inwardly. Though he would never be foolish enough to express it aloud, he was not cowed by this young man. It was his definite opinion that while Borgia was certainly cruel and vindictive, he was often more bluff than anything else.

This time Borgia did not keep him waiting long. "Leonardo, thank you for coming so quickly. I have heard your request to leave my services. Have you not enjoyed your time as my military advisor?"

Leonardo wondered how best to answer such a question and was relieved when Borgia saved him from the decision as he continued, "I have a proposal for you. I would like you to accompany me to Rome. I am overdue

3

for a visit to my father. We can use the journey to further discuss your military ideas."

Even as he nodded, Leonardo wondered how Salai and Tommaso would take the news, but again, Borgia continued without waiting for his response. "I would like to make the trip without attracting attention and therefore would like to take as few extra men with us as possible. Would you be opposed to sending your servants on ahead of you to Florence? If they can be trusted with the task, I would like to send a message with them to the Florentine government. I promise to keep you with me in Rome for only a short time, maybe a week or two, and then you will be free to go back to Florence as well."

Leonardo wondered about such a promise from a man like Borgia, who seemed to break promises on a daily basis, but the news would certainly make Salai and Tommaso happier. "Yes, I believe that would be satisfactory. And I am confident that a message sent with my servants would arrive safely in Florence as you have requested."

Borgia rose abruptly. "Excellent, then it is settled. I will give you the rest of the day to instruct them and get your own affairs in order. We will leave at first light tomorrow morning. I will send for you when I am prepared, and my servant will deliver the message for them at that time."

With that Borgia was up and out of the room. Leonardo turned to leave as well, confident that Tommaso and Salai would be celebrating the news even more than he was. Like them, he looked forward to their return to Florence after more than nine months away. But maybe he could get excited about a brief trip to Rome, even under these circumstances. His good friend Bramante had been after him for too long to come visit him there. Yes, it would be a good distraction before he headed back to Florence

and got back to work. Maybe, just maybe, he would be ready to pick up a paintbrush again upon his return.

Walking back to their rooms, he glanced around at the castle that had been their home for the last few weeks. No, he would not be sad to be leaving.

<center>***</center>

Tommaso and Salai watched out the window for Leonardo. It seemed like he had been gone a long time. Salai wondered aloud whether that was a good thing or a bad thing. Surely Borgia would not be so angry at their request to head home that he would react badly. Tommaso shuddered at the thought of what Borgia was really capable of. Salai had never been as bothered by their close proximity to such a cruel man. But as the months wore on, even he had started to agree with Tommaso. Enough was enough. It was time to head home while they still could.

At last they saw Leonardo heading their direction. Tommaso studied his face, wondering whether the news was good or bad. With Leonardo it was always hard to tell. But at least Borgia had not detained him, so that was good news. Both young men moved away from the window, not wanting the master to know they had been watching for him. They moved off to their area of the small living quarters, knowing it would be best to be available when Leonardo was ready to speak to them, but not wanting to be underfoot.

Entering, Leonardo lit a candle and looked around the space that had been their most recent home away from home. He would have to leave most of the packing to be done by Salai and Tommaso after he left in the morning. Other than gathering a few of his personal items and his most recent sketchbook, there would be little time or space for much else.

<center>5</center>

Without pausing to think about it, Leonardo opened the sketchbook in his hand to the last page he had been making notes on. He turned his notebook sideways, writing in a small gap along one side, "War is the most brutal kind of madness there is." He was cold and he was tired. And he was most definitely tired of being around the violence that seemed to follow Borgia everywhere he went.

The inspection of the region had gone well, but Leonardo had feared his fingers would become frostbitten before he completed his current mapping project. Under other circumstances he would have been reluctant to leave the task undone, but Borgia was not giving him an option. And he was beginning to agree with Salai and Tommaso – it really was time to head home and find new employment.

As Leonardo sat silently, Salai and Tommaso moved towards the fire, trying to decide whether Leonardo was in the mood for conversation. Tommaso nudged Salai as if to encourage him to begin. Salai grimaced as he cleared his throat. "Master, now that Machiavelli has gone back to Florence, will we be able to leave soon too? We have continued traveling with Borgia much longer than we had expected – from Imola to Perugia and now Assisi. And everywhere we go the danger grows."

Hearing the concern in his voice, Leonardo closed the notebook carefully and glanced at his servants with new interest. Sometimes he forgot just how jittery the two young men tended to be at the thought of working so close to the treacherous Cesare Borgia.

Studying them, Leonardo didn't know whether to laugh or frown at their tragic-looking faces. "I am coming closer to completion on my current projects for Borgia. The temporary bridge I made for his soldiers performed flawlessly and my mapping project of this region is almost

completed. There is just one thing, Borgia has asked me to accompany him on a quick trip down to Rome to visit his father, Pope Alexander."

Leonardo paused, watching the crestfallen faces in front of him. "But," he quickly added, "I will be sending the two of you straight to Florence. You will not need to accompany me to Rome."

Both men relaxed a little, but then Tommaso seemed to have a new concern. "But Master, we are supposed to be assisting you. How will you manage in Rome without us? And you still need to be careful around that wicked man. You realize even his wife has left him after his brutal murder of the mercenary captains at Sinigaglia!"

Leonardo laughed off his concern. "Believe it or not, after fifty years on this earth, I still know how to take care of myself. I will send my most prized books and papers back with you, including most of my sketchbooks. You may purchase a small cart and take your time traveling to Florence. Borgia has promised me the use of a horse when I travel home from Rome. I will be fine. You two may go back and make sure I have a studio ready for me to get some work done when I arrive. As little as Borgia has paid me during the nine months in his employ, I am afraid that I will need to take on a paying commission as quickly as possible after returning home."

Leonardo continued his instructions to the two young men. They both appeared to be in shock at Leonardo's sudden announcement, but Tommaso seemed close to tears.

"It will be fine, Tommaso. Cesare Borgia has not harmed me during the nine months I have worked for him; he isn't going to do so now. I will leave in the morning and you two may head back to Florence as soon as you are ready."

They both nodded and Tommaso burst out, "We will be ready to leave by tomorrow also, Master. It will not take us long to procure a cart and pack our belongings. Besides your notebooks we have very little to pack."

Leonardo nodded his approval. "Tomorrow will be fine. Or the day after that. I am riding to Rome and will arrive there quicker than you will travel to Florence by foot. But you needn't hurry. I plan to look up my old friend, Donato Bramante as soon as Borgia releases me. I am confident Bramante will want me to stay a few days so he can show me the many sites in the city he has now called home for several years. So you two will have plenty of time to get back to Florence and get set up."

Salai and Tommaso nodded slowly and Leonardo continued, "I believe we left the Santissima Annuziata Monastery on good terms with the monks there. You may start by inquiring there and seeing if our old studio space is still available. It was a reasonable place to work and live. If it is not, check with Fra. Luca Pacioli. The last I heard he was still in Florence, teaching at the University of Pisa there. He has promised to assist us again if ever the need arises and should definitely have the connections to help you find something adequate. But please keep in mind that our funds are not unlimited."

Salai nodded, but Tommaso seemed too scared to move. He was thinking more about packing and leaving than about what would happen once they arrived back in Florence. Both seemed especially anxious to begin their travels as soon as possible. Leonardo handed Salai a small purse. "There are enough coins in here to obtain a cart and cover your expenses home. I have also included a note to my banker in Florence so you may withdraw a small amount when you get there. You will not have enough money to waste, but your needs will be met until I return. Do not lose the coins or the note," he added sternly.

Salai looked at the ground, knowing the Master had good reasons to be concerned. He had not always been the most responsible young man, but it was not for lack of trying. He was tempted to give the coins to Tommaso, who was much less likely to lose them. But no, the master had entrusted them to him and he would not let him down. He took the purse, tucking it away carefully, and looked back at his master, who appeared to be enjoying his discomfort too much.

"I won't let you down, Master."

"I am confident you won't. I am also quite sure Tommaso will keep an eye on you and the coins, since he hates missing meals at least as much as you do."

That comment brought smiles to the faces of both young men. And neither argued, fully agreeing with the master's assessment.

"Now, it is getting late. I do not want you two staying up late tonight to pack. One of Borgia's servants will be here early tomorrow morning to summon me and to entrust the two of you with an important message for the City Fathers in Florence. You most definitely don't want to lose that note," he warned.

Both men winced before Leonardo continued, "Let's all get some sleep so we can be at our best tomorrow."

Tommaso and Salai both nodded again, knowing he was right, they would both have gladly stayed up late to pack if he would have allowed it. Departing tomorrow as quickly as possible from this area controlled by Borgia and his mercenaries was a top priority for both of them.

Chapter Two

Central Italy

January 1503

The ride to Rome was fairly uneventful. True to his word, Borgia had brought a small contingency of soldiers with him, and provided Leonardo and the others with fast horses. In spite of Borgia's predictions of talks along their route, little conversation actually took place as they rode. Instead each rider focused on the road and his own horse. Leonardo was lost in his own thoughts, giving him ample time to contemplate the last nine months he had spent in Borgia's employ. Leonardo was glad that Borgia had suggested sending Salai and Tommaso back to Florence. He knew they had been exhausted and stressed by the many months he had been in Borgia's employ.

It wasn't all bad, Leonardo thought. *I haven't had much time to pursue my art or science studies while we traveled from town to town, or even when we wintered in Imola. But I have had plenty of time to work on military tactics and to improve my mapmaking skills.*

Leonardo smiled as he recalled Borgia's reaction to the map he had carefully drawn of Imola. Borgia had seemed quite surprised by its detail. Leonardo had merely shrugged, knowing he had simply been doing his job to the best of his ability, as he always did.

Leonardo considered what his job had actually been during those many months. Borgia had brought him onboard as his military advisor, apparently at the suggestion of the wily Machiavelli, another Florentine who had already been in Borgia's employ for several months. But both Machiavelli and Leonardo had had two missions during their long stints with Borgia – keeping him happy with their efforts, while at the same time keeping an eye on him for the Florentines as he cut his way across the central portion of the Italian peninsula. As Borgia had moved closer to the Adriatic Sea and further from Florence, the government officials of Florence had breathed easier, surely relieved by the sporadic messages that both Machiavelli and Leonardo had been able to send their direction.

While Leonardo worked for Borgia his thoughts of him as a ruthless man had certainly not diminished, though Leonardo was happy to have been absent from the vast majority of Borgia's worst outbreaks of anger. And he had actually enjoyed the few opportunities he had had to hold discussions with Borgia – a man who

seemed to have ideas on as many different topics as he himself. On more than one occasion they had talked late into the night. It was a level of conversation Leonardo had had with no one else since leaving Milan.

Even as he thought that, Leonardo had to reconsider. No, that wasn't quite fair. On numerous occasions the talks with his good friend Luca Pacioli had risen to match his prior Milanese discussions and his recent discussions with Borgia. It was only because those had so often turned to religion that Leonardo was dismissing them so quickly. With Borgia, religious conversation was never a concern, in spite of Cesare having actually been a Cardinal with the Catholic Church for a short period of time before striking out on his goal of taking over the entire Italian peninsula.

As Leonardo rode on he enjoyed the feel of another fine horse. He had always enjoyed riding, though since leaving the employ of the Duke of Milan a few years before he had had few opportunities. He supposed it should not have surprised him that Cesare Borgia, son of Pope Alexander, would possess some of the finest horses Leonardo had ever even seen.

Riding on, Leonardo turned his attention to what lay ahead. He still wasn't sure why Borgia had insisted Leonardo accompany him to Rome. Leonardo hadn't yet been to Rome, never having

been closer than the ruins at Tivoli on a previous trip south. But he had certainly heard much about the city. It sounded as if it had none of its past grandeur, with decaying buildings and rubble-filled streets the norm rather than the exception. He had heard that recent popes were determined to make big changes to the city, and maybe things were no longer as bad as they had been. Besides, it would be good to see Bramante again before he returned to Florence.

Chapter Three
Vatican Hill, Outside of Rome
February 1503

When they arrived Leonardo was immediately struck by the difference between Rome and Florence. *Yes, he thought, it will be good to go home to Florence after this.* Leonardo slowed his horse as the small group made its way across the bridge into the city. Of course, like Florence, Rome was a walled city, but these walls didn't seem to have held up as well as the Florentine walls. In fact, Leonardo doubted that these walls would offer much actual protection when the city was attacked.

Their journey ended on the west side of the Tiber River. Leonardo had learned during their travels that the Vatican Palace was located in its own little region, across the Tiber from the main city of Rome. Popes preceding Cesare's father had continued building up the palace area, adding towers and other security measures. Leonardo wondered, not for the first time, who the Popes had as enemies that they required such security. Did the Pope even have his own military advisor?

Well, in a sense, I have been that indirectly, Leonardo thought, *since Cesare has been traveling through central Italy with Papal troops under his command. It is doubtful the younger Borgia would have gotten as far as he has and done the damage he has done without the Pope's blessing.*

As Borgia led the way through the filthy streets to the Vatican, Leonardo could not tell if Borgia was actually

14

happy about seeing his father. Leonardo wondered who had set up this meeting, father or son? Of course, when Leonardo considered his lack of enthusiasm in visits to his own father, he could understand. He wondered briefly if he should pay his father a visit when he returned to Florence, but quickly dismissed the idea.

Leonardo approached the Papal Palace with less awe than curiosity. As they were led inside the Borgia apartments, Leonardo recalled the first time he had heard of them. During his travels for Borgia the previous summer, he had stopped in Siena. There he had been introduced to Pinturicchio and Raphael, two artists hard at work on the Piccolomini Library. The bright, colorful frescoes they had been working on had been quite well executed. Even then Leonardo had seen quite a bit of potential in the younger Raphael. In his conversation with the two men, Pinturicchio had mentioned his commission from Pope Alexander to paint the frescoes in these apartments several years before.

Now, less than a year later, here Leonardo was, about to enter those very apartments. Even more than meeting the Pope, he wanted to see the frescoes. He wasn't always so interested in the work of other artists. In fact, he was hoping to stay clear of anything the young upstart Michelangelo had been involved in here in Rome or back home in Florence. But Leonardo had been impressed with Pinturicchio and his young helper, Raphael. And their work did interest him. If he got a chance to get into the Sistine Chapel, he would study the frescoes painted there by Pinturicchio and Perugino a decade or so before. But if not, surely he could see the ones here in the Pope's apartments.

Leonardo had never thought the day would come when he would miss painting. Certainly not while he was struggling to complete his *Last Supper* masterpiece, or

while he was being pressured to complete this or that portrait. But now that he had been on a multi-year break from painting, he did find himself desiring to get an easel back out, to prime a board with gesso, and to turn the plain white background into a thing of beauty that could outlive him.

The men entered the North wing of the Papal palace and were ushered through several connected rooms. Only a few of the other men Borgia had brought along accompanied them. Leonardo had watched with interest as the others were instructed to stand off to the side while the smaller group proceeded forward.

An elderly man in papal robes greeted them as they entered the room. Leonardo had heard rumors that the Pope's health was failing, but it certainly wasn't evident in what he was seeing of him. Leonardo followed Borgia's example, bowing slightly as they came closer to the Pope. Borgia kissed his father's hand as it was offered to him, and then stood back for Leonardo to do the same. "Father, I believe you are familiar with the work of Leonardo the Florentine. He has been in my employ for these last many months."

Pope Alexander smiled slightly. "Ah yes, the great Leonardo. I am surprised my son would employ you to advise him in military matters, considering the quality of your artistic work. I really must stop in Milan and see your *Last Supper* fresco the next time I am that far north."

Leonardo smiled slightly, a little embarrassed that the Pope would even be aware of his mural. He considered correcting the Pope and letting him know that it wasn't a fresco, but thought better of it. Instead he merely nodded.

Borgia was the next one to speak. "I had no need these last months of his artistic talents. But perhaps, someday, if I am here in your position, I will hire him for some painting or another at that point." Leonardo was

surprised when the younger Borgia turned slightly and winked at him before continuing, "But his talents in military matters equal or exceed his artistic ones. So I have still benefited from his assistance. Perhaps you could use some help in those matters as well, Father?"

Leonardo was surprised when the Pope snorted in response. "No, I think our military requirements are being met. The King of France is gone. The Spanish are no longer at our doorsteps, and the Turks have gone on to other matters. Speaking of the Turks, Leonardo, I have had correspondence again from the Sultan about you. He may actually be looking to hire a multi-talented man such as yourself. After your unusual bridge design, I believe he has been looking for a task that would convince you to come to Istanbul. Or Constantinople, as we would generally call it."

Leonardo was surprised when a servant appeared suddenly at the Pope's side. Alexander leaned over and whispered loudly to him, "Go to my desk and bring the latest correspondence from Sultan Bayazid. I believe there is something there concerning Master Leonardo."

As Leonardo waited, Alexander continued, "Bayazid was quite taken with the letter you sent him about your engineering ideas for special mills that are powered by wind rather than by water and the self-propelling machine for extracting water from ships without the use of ropes or cables. Now that he has the Spanish Jews comfortably settled in his land, he is looking at your suggestions. So, tell me, Leonardo, are you preparing to depart for faraway lands?"

Leonardo shook his head. It had more than a year now since he had contacted the Sultan about his ideas, first for the bridge across the Bosphorus Strait and then with his other engineering ideas. The bridge plan had actually been in response to a request that Bayazid had

sent to Rome with several ambassadors. Leonardo had assured the Sultan that his bridge designs would work. He had sent one for a drawbridge and one for a bridge with a high enough arch that ships could pass under it. When his plan had been rejected by the Sultan's advisors as being impractical, Leonardo had followed that plan up with several other suggestions. But there had been no positive response from the Sultan at that time, and now enthusiasm on his own part was a thing of the past. Now that Leonardo was in his fifties, the idea of traveling so far held no appeal to him.

"No, your excellency, I no longer hold desires to visit Constantinople and the surrounding areas. In my youth I might have considered leaving the Italian peninsula for such an opportunity. But not now. In fact, I am looking forward to returning home to Florence when I leave here."

Leonardo was surprised that the Pope didn't seem taken aback by his negative response. At that moment the servant returned with several sheets of paper in his hand. Alexander glanced quickly at the papers and then handed them to Leonardo. "The Sultan has become accustomed to being turned down by Italians. In spite of his best attempts to steal away some of my best artisans, he has had little success. You may take his latest letter and respond to him as you see fit. It will be of no consequence to us if you do not go. Our need for his assistance in other foreign matters has ceased."

While Leonardo took the letter from the older man, he caught himself looking around the room more. He noticed that the room was actually the Pope's study.

Leonardo had heard that in the five decades since Gutenberg's printing press popes had been quite the collectors of books. The collection around him did not rival the libraries Leonardo had been acquainted with in Florence or Cesena, but it may have been the largest

besides those. The Pope caught Leonardo's glances around the room and smiled. "Ah, Leonardo, I have heard that you share my love of great things. I am afraid this is one trait that my son has not picked up from me. You may want to come back at another time and take a look. There are more books in the Vatican Library than are found here, but these are some of my favorites. Pope Sixtus began construction of the library and I have worked hard to add to what my predecessors started."

Cesare interrupted his father, clearly not interested in the topic of his books. "Father, we have ridden far on our journey to Rome. Please forgive us if we don't stay up late for tonight's revelries."

The Pope nodded. "Of course. There will be plenty of time for parties while you are here. My servant will show you to your rooms and see that anything you need is provided. Be sure to join me tomorrow evening for dinner and we will discuss your time in Rome further."

As they exited Alexander's study, Leonardo finally took notice of the walls they were passing, realizing at last that he was almost surrounded by frescoes of religious scenes. He wondered if Cesare would mind him stopping and taking a look. But just as quickly as the thought had occurred to him, Leonardo realized how tired he really was. Art would have to wait for another time.

As the men were shown to their rooms, Leonardo wondered if he would be expected to join Borgia the next day. He really wanted to go see what his good friend Bramante was up to, and had heard enough about Borgia parties to have no desire to attend one.

Borgia stopped at his own door. "Leonardo, you need not feel obligated to join me tomorrow when I return to my Father's apartment. I wanted you to meet him, and to hear the news from the Sultan, but I don't think

tomorrow's festivities here at the Vatican will be of interest to you."

Leonardo was surprised that Borgia had even realized that. "Excellent. I would like to go visit with Donato Bramante during the day tomorrow. So I will not be concerned about when I return in the evening."

Borgia nodded and then surprised Leonardo yet again. "I have appreciated your assistance for the last nine months, Leonardo. You may consider your obligations to me officially over at this point. My father's guards have been instructed that you are welcome to come and go here at the Vatican as you wish. This room will be available for your use as long as you have need of it. If you want to see more of the art or literature here at the Vatican at any time, my father has already given his blessing. When you are ready to depart for Florence, whether in days or weeks, send word to me and I will assure you are provided with the use of another good horse, as we had discussed. In the meantime, have a good night and a good visit."

And with that, Cesare Borgia, the most ruthless man Leonardo had ever encountered, let himself into his own room. Leonardo stood outside the neighboring door, wondering for a moment if he had heard correctly. Finally he opened his door, wondered briefly how Salai and Tommaso were faring, and headed to bed.

Chapter Four
Arriving in Rome
February 1503

Leonardo awoke fairly early the next day and set out to see a bit more of the city while he hunted for Bramante. Refreshed from a surprisingly good night's sleep, he was content as he set out alone. He strode first towards the Castel Sant'Angelo, that towered over the road and the river. As he crossed the Tiber he was careful to stay out of the way of the pilgrims that were heading towards him, and beyond him, towards St. Peter's.

As he walked the Roman streets he could see that many of them were being widened. Leonardo paused as yet another interesting ruin came into view. It surprised him how many of the ancient ruins still survived in Rome. He had seen occasional ones in the villages and cities to the north, to be sure, but this seemed to be a city built around and over ruins.

After a bit more exploring, Leonardo found a helpful looking young man and asked he knew of the artisan workshop of Donato Bramante. The young man smiled. "Master Bramante, of course. You will have no difficulty finding it. Head back towards the river and then continue south and east along it. When you encounter the massive open air theater you will know that you are almost there. Continue on along the river for one more block. If you get to the stone bridge you've gone too far. Soon you will see the San Bartolomeo Church on an island in the middle of

the river. Head inland just a block and you should find yourself facing Master Bramante's studio."

Leonardo followed the directions, located the studio, and walked briskly into the main room. It was difficult to contain his excitement at seeing his friend again. As his eyes adjusted to the poor lighting of the room, he saw Bramante leaning carefully over a large sketch spread out on the table in front of him.

Leonardo approached the stooped figure. "Donato, it has been too long."

Bramante turned quickly to face his friend of many years. "Leonardo, what a surprise. I hadn't heard you were in Rome. What brings you to the city after all this time?"

As Bramante spoke he was brushing dust off two chairs that sat off to the side of the table. Leonardo took the closest one, lowering himself carefully into a seat that looked like it had seen better days, and then turned back to his good friend. "I have come with Borgia, at the request of his father, the Pope."

Bramante looked surprised. "Are you coming to join the papal artists? I hadn't heard, but I would love to work with you again, Leonardo."

Leonardo thought back to the many years he and Bramante had worked side by side in Milan, working to bring art and architecture to the Duke's court. He wondered how it would feel to work for one such as Pope Alexander, but he shook off the thoughts before he answered. "No, nothing like that I'm afraid. Apparently the Ottoman Sultan has sent ambassadors to Rome again to request help from the Pope. He is looking for a designer for a project he has in mind. Since Cesare was heading this direction, he thought I should come along."

Bramante contained his disappointment that his friend would not be joining him on the papal payroll, but he

was more than a little intrigued by his friend's announcement.

"The Sultan? What type of project does he consult with the Pope about? I would have thought the Sultan would have had architects and engineers on par with any of us here in Rome."

Leonardo smiled at his friend's modesty. "It is highly unlikely that he has any the equal of you, my dear friend. But apparently, he is once again desirous of building a bridge over the Bosphorus Strait and can find no engineers amongst his own that can handle the size of the project it would require. I have been asked to try my hand at it. In fact, I submitted a design for it some time ago."

Bramante moved papers around on his crowded table until an appropriate sized blank one appeared. He slid the paper towards Leonardo, "Do show me."

Leonardo quickly sketched an arch bridge with wide bases on each side – showing his idea from both the top and the side.

"The plan I submitted looked something like this. Donato, what do you think? Unfortunately, the Sultan did not understand the feasibility of the design and his advisors convinced him that an arch bridge of these dimensions would not hold up, I am still convinced that it is a perfectly workable plan."

Bramante turned the paper this way and that, studying the sketch. "The design is stunning, Leonardo. I wish the Sultan could see his way to have it built."

Leonardo shrugged. "It's highly unlikely and I no longer wish to travel so far. The Italian peninsula offers me enough to content me for a lifetime."

Bramante continued studying the hastily drawn sketch. "Vitruvius would have seen the workability of this design, Leonardo."

Leonardo smiled at his friend's compliment. They had often studied Vitruvius when they worked together in Milan. "I like to think so," he finally added. "Unfortunately," he continued, "a Vitruvius stamp of approval would not be likely to convince the Pope or the Sultan at this point."

Before Bramante could comment, Leonardo changed the subject. "But enough on my design, Donato, what have you been doing since coming to Rome?"

Bramante smiled. "As you know I came to this area when Duke Ludovico lost power. Like so many artists and architects I came in hopes of working for the Pope. But my distraction when you met me at the Tivoli ruins has continued for the last three years. I have been researching the Roman ruins – inspecting and measuring them, determining how they were built and what we can do today to follow their example. I have not done much of my own architecture since arriving; the study of the ancient must come first."

Leonardo nodded in appreciation. He could still remember Bramante when they had met up the previous year, covered in dirt, sketching and measuring, observing and calculating.

The two men discussed Bramante's work further before coming back to Leonardo's presence in the city.

"So are you here for long, Leonardo? You have chosen a really good time to visit Rome, or a really bad one, depending on your point of view."

Leonardo waited for him to continue.

"It's almost the start of Lent, so the city is deep into its celebration of Carnival. Are you familiar with that tradition?"

Leonardo groaned and nodded his head, suddenly understanding why Borgia hadn't pushed for him to join the upcoming celebrations at the Vatican. "Yes, unfortunately I'm quite familiar with it. Florence and Milan may both have

the good sense not to get caught up in the debauchery of Carnival. But three years ago Luca Pacioli and I arrived in Venice at the end of Carnival. I can't say there was much about the celebration that appealed to me."

Bramante nodded his head in agreement. "I've been told that the celebration of Carnival in Rome is quite different than their celebration in Venice, but I understand both cities work hard to celebrate the depravity of man during that time. I also find the traditions around it in both cities to be distasteful."

Leonardo nodded. "I am sure I will feel the same way here. I know how to have a good time as well as the next man – through song and dance and drama, but I see no value in the Carnival type of nonsense. How long will I have to endure it this time?"

Bramante smiled slightly. "The good news is it's almost over. Only two more days. We should be able to avoid the worst aspects of it. We can save our big tours of the area for a few days until at least a little sanity has returned to the city. Surely you can spare at least a few days before you have to leave."

Leonardo smiled appreciatively, happier at the prospect of spending the next few days with Donato rather than with the Pope and his family, especially knowing the type of merrymaking that was likely to be happening at the Vatican.

Bramante changed the subject back to Leonardo and his work. "So, are you considering staying longer? I would love to have you work with me again. You were a big help to me in Milan when I was working on the design for the changes to the Santa Maria delle Grazie church that the Duke wanted."

Leonardo took the compliment graciously, but shook his head. "No, I have struck an agreement with Cesare Borgia. My trip down here completes my obligation

to him as his military advisor. I have sent my servants on ahead of me to Florence, and I look forward to joining them. I believe it is time for me to do some painting again. But, I'm confident our paths will cross again sometime in the future."

"Well, certainly they won't be expecting you back in Florence right away. Give me a few days to show you what Rome has to offer. We can examine some of the ruins this afternoon, and then you can dine with me this evening. We will stay close and then dine in to avoid the Carnival craziness."

Leonardo readily agreed. "It sounds like you have taken up Brunelleschi's work of examining and cataloging the ancient ruins. I would love to see what you have discovered."

Leonardo was surprised that Bramante frowned at his remark. "I am attempting to find and document the ancient architecture, but the popes and cardinals seem as anxious to reuse what is being found in their own villas and churches as I am to preserve it. I am afraid we will have no ruins left in their original locations by the time this century comes to an end. But enough, that is not our present concern. I must take you to see some of the ancient joys that Rome still has to offer."

Leonardo followed his friend out into the street. As they walked together through the crowded, filthy streets, Leonardo expressed his disgust at the city. "I don't know how you live here after all the years we spent in Milan. I must say I look forward to returning to Florence where the city appreciates culture and art, and has some understanding of the importance of cleanliness."

Bramante shrugged. "I have resigned myself to it. The ancient architecture brings me enough pleasure to compensate for the filthiness of the city as it exists today."

Leonardo frowned as they continued to walk carefully around the debris that seemed to be everywhere. "It is beyond belief that people still live like this. I am surprised that the Pope allows it."

Bramante's eyes twinkled at his friend's comment. "Even the Pope cannot control such things, in or out of the walls of the city. Much of what you see is actually the result of the papacy deserting Rome for more than a century. Now that the Pope has returned to Rome where he belongs, the city is slowly regaining its previous beauty. But the neglect was so bad for so long that it is sometimes difficult to imagine the city ever fully recovering."

Leonardo nodded. He was certainly having difficulty imagining it. Bramante continued, "Look over there on the hilltop, where the sheep and goats graze. They make themselves at home on all seven of the city's hilltops. What the animals have not taken over, the grass simply has. The aqueducts were neglected for so long that most of them still don't work properly. Malaria is bred in the swamps surrounding the city. I wish we had both seen the city before all this."

"Indeed, for this is quite a mess."

"As hard as it may be to believe, it is improving. Pope Martin brought the papacy back to Rome in 1417, though I think he was rather overwhelmed by the state it was in when he arrived. When Pope Nicholas came into power three decades later he worked hard to reconstruct the aqueduct closest to the city and even had Leon Battista Alberti build a fountain for it. Soon after that, Pope Sixtus had a new bridge built to connect the city to St. Peter's to make it easier for pilgrims to get to the cathedral. It was the first bridge built over the Tiber River since the days of the ancients. Alberti had a hand in that construction as well."

Leonardo thought back to the crowds he had seen earlier in the morning as he crossed over on the bridge in front of Castel Sant'Angelo. Worse crowds than that? No thank you.

Bramante took a breath and paused from his short history lesson. "You've read Alberti's book On the Art of Building, haven't you, Leonardo?"

Leonardo nodded. "I have purchased a copy. It was one of the reasons I have worked for so long to better my Latin. I would prefer a copy in Italian, of course, but thus far I don't believe it's been translated."

"I have only seen it in Latin as well. But it is well worth the effort to read. Alberti's work in the world of architecture has influenced me as much as that of Brunelleschi."

Both men had stopped walking, each deep in thought as they observed the fascinating architecture that seemed to grow out of the ground around them.

Bramante broke the silence. "Pope Alexander has been transforming Emperor Hadrian's mausoleum into a fortress suitable for any leader. You probably saw it earlier, the Castel Sant'Angelo, not too far from the Vatican.

"Yes, it's where I crossed over the Tiber River. I hadn't realized it had a connection to Emperor Hadrian, but I was quite struck by its size. It looks like it would do quite well as a fortress."

"Pope Nicholas connected it to St. Peter's with a fortified, covered corridor almost half a mile long. I heard that Pope Alexander used the corridor to escape to the castle when Charles VIII invaded the city. You and I were still in Milan at the time, so I've only heard stories of the invasion."

Leonardo found himself thinking back to the many days they had worked together in Milan as Bramante continued, "With all the extravagant churches and homes

28

the popes have been building, I believe that in time the city will regain its architectural glory. It may someday even make Vitruvius proud again."

Suddenly, Leonardo paused in front of a large, long field. Not much remained to show what it had been and he climbed up on a small hill for a better view. "A race track?"

"Yes, a circus, the largest one the Romans had, the Circo Maximus. Apparently chariot racing was quite popular here for hundreds of years. More than 100,000 spectators could crowd the wooden grandstands on either side of the track to view the races."

Leonardo stood gazing down the long narrow space, imagining it as it had once looked. Then, closing his eyes he let his imagination loose to smell the horses and the fear, to hear the shouts and the applause, to see the winners and the losers. When he opened his eyes, he could see that Bramante had had similar thoughts.

"People died here, on this track, in those races," Bramante finally stated quietly.

"And horses died, Donato, too many horses. Let's not forget that." Shaking his head as if to remove the sad visions, Leonardo continued, "Where to next, Donato? Where to next?"

"Not far from here we can see some of the inner city walls, the Servian Wall. It is the extent of Ancient Rome more than two thousand years ago."

For the next twenty minutes the two men walked in silence, neither straying far from the pictures that were playing in their minds of the races that had played out on this track.

At the end of the grassy field that indicated the far end of the Circus they crossed over a road and Bramante pointed at what was left of an ancient, crumbling wall. "As I mentioned, this was the first set of walls, the inner walls. As you can see here and in other places, there's not much

left after so many centuries. But there are places throughout the city where more of it survive. Let's continue north a bit and you can see what's left of one the gates, the Arch of Dolabella."

Again the men walked and talked, this time both observing the ground for signs of the long unused wall. Leonardo was surprised to find himself suddenly facing a portion of wall that was quite intact. They walked around the gate, admiring the arches at the lower and upper levels.

"You will find," Bramante spoke almost reverently, "that the Romans made good use of the feature of the arch. We will find arches in the vast majority of ruins where there is still enough to see."

Leonardo walked slowly around the gate and Bramante was not surprised that his friend had removed his sketchbook and started quickly drawing. After a few more strokes of his chalk, the book was just as quickly tucked back into its place in his robe.

"Come, Leonardo, there's much more we can see today. We'll continue along the remains of the wall for another mile or so to the northeast. Then it makes a sharp change of direction to the northwest and after another mile or so will bring us almost directly to the Baths of Trajan, another set of ruins you really must see."

Leonardo looked down at his feet and smiled. "I'm glad I wore my walking shoes, Donato. It seems that we will be doing quite a bit of walking today."

Bramante smiled. "I doubt you are ever without something comfortable on your feet, Leonardo. You are too practical a man not to be ready to enjoy whatever road opens itself up to you."

Before long the men were looking up at the remains of a massive circular building. Leonardo did not hide his

amazement. "I had no idea so much of a building like this would still exist after more than a thousand years."

Bramante smiled again. "The fact that it is a bit farther out helps. It would not have been as convenient to borrow or steal the stone from here and reuse it in the modern palaces that seem to be springing up everywhere. The Colosseum is enough closer in to make it the more likely target. So, I believe it remains in much the same shape it has for centuries. But come, take a good look around the Baths of Trajan before we move on to see the Colosseum."

Leonardo walked around the entire complex, imagining the building in the days of the Roman Empire.

Bramante interrupted his thoughts. "Right on the edge of these ruins you can see what remains of the Baths that Emperor Titus had had built here. When Emperor Trajan had this larger bathing complex built almost right next to it, the Baths of Titus were allowed to deteriorate, and as you can see, there's very little of that original bathing complex remaining. But we can at least see where it was and how small it was by comparison to Trajan's."

Leonardo and Bramante walked the length of the smaller set of ruins before Leonardo remarked, "It's no wonder that the original baths were replaced. This is such a smaller area."

Bramante nodded in agreement. "Trajan's Baths are quite large, but if we have a chance we'll go by the ruins of two larger ones at a future time. But before we leave the Esquiline Hill, I must tell you what was recently discovered here. Remains from Nero's palace, the Domus Aurea, were found under the Baths of Trajan. In spite of the magnitude of its size and the opulence of its decorations, until recently it had been believed that nothing remained of his palace. Large portions of it were discovered under the baths. Some of the younger artists

31

have been lowered down into the passages by rope and have been studying the murals down there by torchlight. While I am sure we would both love to see the fantastic paintings they are discovering, I'm afraid we will have to leave that type of research to men quite a bit younger than ourselves."

Leonardo considered arguing with his friend, but thought better of it. He had to admit that now that they were both in their fifties, there were indeed a few things that were outside their abilities, if not their desires.

After enjoying one last look at the area of the baths, the two men continued walking back towards the central portion of Rome. Soon Bramante was pointing just a little ways in front of them. "I believe you and your servants have seen the amphitheaters at Verona and Rimini. But you will quickly see the largest amphitheater the Romans ever built. It is an architectural and historical wonder. And it too has a connection to Emperor Nero."

As they drew closer to the structure, Bramante explained. "After so much of Rome burned, Nero had built his palace over an extensive portion of the city, extending much beyond the Esquiline Hill. Here, in front of us, he had built a lake for his palace. Almost as soon as he had died, successive emperors were working to remove what he had built. His lake was filled in to build the Colosseum."

Leonardo smiled. "Salai and Tommaso might have endured a trip to Rome to see this. But how has it survived the passage of time?"

Donato shrugged his shoulders. "It had actually survived fairly well – until the time of Pope Nicholas. After it had stood for more than a thousand years, he ordered it demolished."

Leonardo was surprised. "But I can see that most of it still stands."

"There is certainly enough of it left to fully appreciate how large it was and how remarkably well designed it was. But while Nicholas was pope more than two thousand cartloads of stone were removed from it. I'm not sure if he was planning to reuse all that stone, or if, like us, he was troubled by the Colosseum's past. Nothing I've found seems to clearly indicate what his motives were for wanting it demolished."

Leonardo nodded sadly. "Much of the Roman era seems to me to be a paradox – so much good combined with so much evil."

Donato wondered if his good friend would be amenable to another philosophical debate on that topic, but worried about their limited time together. "I had hoped to show you several other things today from the Arch of Constantine to the Roman Forum. But those and the many ruins on Palatino Hill will have to wait. If we want to be off the streets before the Carnival revelries begin, we should return to the studio now for a light supper. Maybe we will still have time for a short music session before the day finishes."

Leonardo smiled appreciatively. He and Bramante had often made music together in Milan and more recently in Tivoli. They were both quite adept at playing the lute.

Chapter Five
Touring Rome

The next day the two men continued their walk through the Roman streets in search of interesting sites. As they walked they turned their conversation back to Vitruvius and his role in so much of the ancient architecture they were seeing. Bramante stopped suddenly, pointing at a set of ruins in front of them. "This is believed to be where Julius Caesar was assassinated by Brutus and Cassius."

Leonardo wondered whether after so many centuries the location could truly be known, but he still liked the thought of being so close to important historic events, in location if not time.

Bramante seemed to sense his skepticism. "We know from historical records that Julius Caesar was in front of the Theater of Pompey when he was killed. And we know from architectural studies that this area, in spite of its current condition more than a millennium later, was where Pompey's theater was located. But come, let me show you something that has survived the passing of time much better."

They continued up the road a short distance to the Pantheon. As they entered the large bronze doors at the entrance, Bramante spoke first. "When I designed the dome on the Santa Maria delle Grazie, I had only the Duomo in Florence and sketches of the ancient world to guide me. But now, I can walk through the ruins here in Rome and more easily visualize the writings of Vitruvius.

When I come to the Pantheon, I stand here in the center in awe, and wonder how the ancients designed and built such a marvel fifteen centuries ago."

Leonardo walked around the large open space, taking it all in. "The dome is magnificent. I would love to know how they managed to build such a large concrete dome so many centuries ago. Do you think, Bramante my dear friend, that anything we are designing or building, painting or sculpting, will even be around to be admired in a few centuries, let alone fifteen?"

Bramante shook his head. "It is hard to imagine. We don't build things with the same eye to the future that men like Vitruvius did. When I stand here under this magnificent dome I can almost hear Emperor Hadrian moving through the building and inspecting the work of his architects."

"It would have been a sight to behold. Does water come in through the opening there at the top? I'm surprised that that has not caused damage."

"Yes, it is completely open there in the middle of the dome; but, no, the ancients planned for that well. The water drains off quickly and causes no damage."

Leonardo continued his walk through the awe-inspiring building. "This is a church now, but it wasn't originally built as a church was it?"

"Not really. It was built 'to all the gods' – so not at all a church in the sense that it is today. This repurposing didn't happen until the seventh century. But come, we must examine some of the other ruins that Rome has to offer. Are you sure you won't extend your visit? You are one of the few men I know who will fully appreciate what's left of the ancient architecture here in Rome."

Leonardo shook his head. "My appreciation pales by comparison to yours, my dear friend. But, no, I really must return to Florence soon. I might be able to spare a few days, possibly even a week, but certainly no longer

than that. Cesare Borgia was as harsh a pay master as he was anything. He has agreed to lend me one of his beautiful stallions for my return trip to Florence. But if I tarry in Rome too long I fear he will change his mind. And I prefer not to walk back to Florence this time."

"I understand your concerns, but you simply must allow me to show you some more of Rome. There is so much about this city that fascinates me, Leonardo. I know you would enjoy being here and seeing and learning so much. If you don't plan to move here, and are not likely to return any time soon, you simply must stay long enough to see the highlights. Who knows when either of us will have the opportunity again."

Leonardo finally relented. He was anxious to get back to Florence and begin painting again, but Bramante was right. They were both here and he should take advantage of the chance to see some ancient Roman remains while he could.

Leonardo suddenly realized that one thing had been missing from their grand tour. "Donato, I know you have been studying the ancient ruins, but haven't you also done some construction of your own? I would certainly be amiss to not see the product of your hands while I am here taking in the efforts of so many others."

Bramante smiled, happy that his friend thought so highly of his work. "I wasn't sure how many churches you would want to see while you were here. Most of my work in Rome has been with the ruins. But last year I completed a small chapel on the Janiculum Hill. It is believed to be on the location where St. Peter was martyred. It's shaped like a circular temple, complete with a small dome. We nicknamed it the Tempietto. But we will need to save a visit to it for a future day; it is on the other side of the river, and not particularly close to where we currently are."

Leonardo nodded his understanding and Bramante continued, "But, I am also almost finished with a project at the Santa Maria della Pace. We are not far from that church, so we can walk over there now. It's a rather small project. I was asked to redo the courtyard there. It's not much, compared to what I've done on other churches in northern Italy, but I've still been able to incorporate arches into the work. And because it hasn't been an all-consuming project, it allowed me plenty of time for my work amongst the ruins."

Leonardo could certainly appreciate the desire to do more than the projects that paid. He had a momentary pang of jealousy as he thought of how little time he had been able to spend on his true love, his scientific studies and experiments over the last year. In addition to getting back to painting when he arrived in Florence, he knew he also had to spend more time focused on science. Both those areas had been sadly neglected during his prolonged service to Borgia.

<center>***</center>

The next morning both men were up and ready to go fairly early. Bramante finished giving instructions to several of his apprentices, and then turned to his role as tour guide. "I know you are not a particularly religious man, Leonardo, but there are two older churches here that you simply must see. Santa Pudenziana has amazing fourth century mosaics and Santa Prassede has ninth century mosaics."

"I would love to see the mosaics there and compare them to the many mosaics we saw several years ago when Fra. Luca Pacioli and I were staying briefly in Venice."

"Excellent. From there I will only tire you with one more church – you should also see the Santa Maria Maggiore. Not only does it have fifth century mosaics, but

<center>37</center>

the Pope has gilded its ceiling with the first gold from the New World."

Leonardo quickly agreed to visit the three churches. As they walked he questioned Donato about the gold. "What was Pope Alexander doing with the first gold from the New World?"

Donato smiled. "As a Spanish pope he has maintained ties with the Spanish monarchs. When Cristobol Columbus first returned from the New World he presented Ferdinand and Isabella with the gold he had brought back. They wanted to be sure that their future explorations were equally profitable so they sent it to Alexander as a gift."

As they moved from church to church, Leonardo carefully studied the mosaics in each location, certainly glad that they had made the time to visit them. He also contemplated the idea that a tribute to the Pope was somehow supposed to make journeys that were going half way across the world successful. But it was clear to him that he would never understand these religious ideas and he gave up trying.

As they finished looking at the mosaics, Bramante studied his friend. "Have you had enough touring, Leonardo? You seem to be slowing. I did have one other thing to show you, but we can head back if you prefer."

"No, no, it's fine. I was merely considering some of the things you had said. If you are up to more walking, then I certainly am too."

Bramante smiled at the not so subtle reference to his age. "I'm not even ten years older than you, not even sixty yet."

Leonardo merely smiled. "What else did you want to show me, Donato? More churches? More mosaics? You were right, these churches have contained some remarkable mosaics."

"I knew you would consider those worth the time. When we were at the Baths of Trajan, I had promised to show you the remains of the largest public baths in the city, the Baths of Diocletian. Like the Baths of Trajan they were built just inside the Servian Wall. They are almost due north of here and we can see another portion of the wall near there as well. I think that site will conclude our touring for today."

<p style="text-align:center">***</p>

Leonardo awoke with a smile on his face. He had finally relented to Bramante's requests of a few more days. If Bramante could take a week away from his work to play tour guide he could certainly spare a week before getting back to Florence and going back to painting. Besides, he had to admit it was nice to be in the company of someone with similar passions and interests. Surrounded by history, art, and architecture they were both truly in their element.

"So, Master Bramante, what is on our agenda today?"

"I'm glad we have both taken to waking early, Leonardo. I have packed us both small parcels of food to take with us. Today we are going out to the farthest walls of ancient Rome, to see some of the remains of the Aurelian Wall. Much more of it remains than the older Servian Wall, particularly the gates. There were apparently between sixteen and eighteen gates when it was built, and most of them are still standing in pretty good shape."

"Whatever you think is best, Donato. I have thoroughly enjoyed the other sites you've taken me too."

"Good. We can head almost straight south from here, along the edge of the Circus Maximus. That will bring us to the San Paolo gate and the Pyramid of Remus. When we're done there, we will head east and north."

"A pyramid? Now, I must say Donato, that is not one of the things I was expecting to see while I was in Rome. I

<p style="text-align:center">39</p>

knew the ancients had brought a fair number of columns and obelisks up from Egypt, but I didn't realize they had included a pyramid in their desire to incorporate Egyptian features into their architecture."

"Come, let's walk and talk. I can give you another history lesson while we are heading there. After Egypt became a Roman province there were actually two pyramids built here in Rome. I believe it was about 30 B.C.. The pyramid of Romulus was built in the area you walked on your first day here, between the Vatican Palace and the Castel Sant'Angelo. As you saw, or didn't see, it no longer exists. Pope Alexander had it dismantled in order to use the material for continued work on improving St. Peter's. Though personally I think St Peter's, thanks to time and neglect, is almost beyond improving."

"I had heard that as well. But go on, Bramante, you were going to tell me about the Pyramid of Remus."

"Yes. It was built ten or fifteen years after the Pyramid of Romulus. It stood alone to the south of the city until the Aurelian Wall was built three centuries later, at which point it was incorporated into the wall. It is really quite the sight, and is in remarkable condition for being more than fifteen hundred years old."

"Excellent. Since I do not foresee going to Egypt in my lifetime, a trip to the pyramid here in Rome will have to do. Are we planning to do the entire Aurelian Wall after that, Donato?"

Donato laughed. "As much as I would love to say we had accomplished that, I think that is another task best left to those much younger than us. Had we come here several decades ago, we could have raced from one gate to the other. But I believe we will both be more content walking at a leisurely pace. So, no, I don't expect us to make our way all the way around the city. If we don't get too distracted along the way, we should be able to make it

to the Tiburtina Gate without too much difficulty. Then we can follow the Via Tiburtina back into town. That road brings us right to the Forum of Trajan and the Roman Forum, which would be a good place to end our tour for the day."

The next morning Leonardo decided it was time for a change of pace. "I enjoyed seeing the gates and portions of the Aurelian Wall that still exist. But I think today we should skip seeing the remaining gates to the north and do something different. You have been doing a great job showing me the ancient art and architecture that have survived here through the centuries, even amongst the neglect and the abuse. I think today we should go and look at some of the newer art and architecture. I think there are some things at the Vatican that we would both enjoy seeing."

Bramante hesitated and Leonardo continued, "The Borgias have given me an open invitation to come back and explore the Vatican. It would likely be considered as an insult to them if I didn't take them up on that invitation and we both know how bad an idea that would be."

When Bramante still didn't agree, Leonardo finally asked, "Are you avoiding Pope Alexander for some reason?"

Laughing, Bramante had to admit that in a small sense he had been avoiding him. "He has been surprisingly generous with the commissions he has given me. But I'm reluctant to take on any additional work at this moment. My apprentices are keeping quite busy with the tasks I've already assigned them. And when you depart I am planning to get back to my personal assignment of cataloguing and measuring the remaining ruins. My concern is that a new commission would jeopardize my work. I am so close and want to see it to an end."

41

Seeing the understanding mixed with disappointment on his friend's face, Bramante finally agreed. "Yes, that would be enjoyable. And now that the revelries of Carnival have come to an end, it might be a safe place to be. Most likely everyone there is still exhausted from their celebrations, and will leave us alone."

"Agreed. Let's head over there now before we find some other distractions. There are some fresco paintings in the Sistine Chapel that I've been wanting to see. And some other artwork in the Borgia apartment that we may be able to see if the Pope is busy elsewhere. I met the young Raphael in my travels for Borgia. He was telling me about some of what we'll be seeing. I think that young man has some real talent. He promised to come to Florence and see me sometime after I return. I think it would be a reunion that we would both enjoy."

Bramante's thoughts went quickly to the young Michelangelo, another new artist who had appeared on the scene fairly recently. He had heard rumors that Leonardo and Michelangelo had not started off a relationship with quite the positive beginning as he and Raphael, so he thought better of bringing him up.

When the two men had thoroughly enjoyed the art of the Vatican Palace they crossed over to St. Peter's. Bramante was quick to point out, "I think one of the saddest buildings in this city is St. Peter's. It was supposedly built over a shrine that had marked the burial place of St. Peter. It has been here less than twelve hundred years and look at the shape it's in."

Leonardo had to admit that the church looked like it could fall down at any point, and Bramante continued, "It was completely neglected while the popes were away. Several of the popes have tried to restore it to its original glory since they returned, including, most recently, Pope

Alexander. But I don't know how much they can really undo the damage that has come during the long years of neglect. At this point do they keep trying to prop it up or just start over?"

As Leonardo walked around the building, he didn't see any good answers. Even as the two men discussed it, the pilgrims continued to stream in and out. "It is apparently a very popular place for the faithful to flock to, Donato. Could a pope really afford to tear it down?"

"About the time you and I were being born, while Pope Nicholas was ordering the demolition of the Colosseum, he was also discussing rebuilding St. Peter's with Alberti. Obviously they didn't rebuild it, but some work was done to maintain it. But as you can see, there was only so much they could do with a structure that had been neglected for so long."

"I would have to agree that continuing to patch it up like they have been doing seems to be doing only limited good. Another question, Donato. Are the walls I'm seeing around the Vatican Palace and St. Peter's considered to be part of the Servian Wall or the Aurelian Wall?"

"No, neither. When St. Peter's was sacked in the ninth century, Pope Leo constructed a wall on this side of the river to enclose the Vatican Hill. He extended it all the way around the hill, enclosing St. Peter's and the Vatican Palace for the first time, and even took it down to Hadrian's Mausoleum, or what we now call the Castel Sant'Angelo. Between the forty-foot-high wall, forty-four towers and the Tiber River, I am sure they feel quite safe here now."

Leonardo walked in front of the Leonine Wall across from them and tried to imagine forty-four towers in a wall of such a small distance. Changing to his all too frequent role of military advisor he decided that forty-four was probably a bit excessive. *Though I guess it would have gotten the job done,* he thought.

43

Chapter Six

Leaving Rome

February 1503

After a few more days of touring, Leonardo took his leave of Bramante. He was happy that his old friend had found productive work here in this cesspool of a city, but he had already stayed longer than he had originally planned. He was quite certain Salai and Tommaso were busy worrying themselves to death in Florence.

Seeing the city with his old friend had certainly made it more interesting. But no amount of asking on Bramante's part could convince him that this was where he wanted to live or work. Even if the Pope himself asked, Leonardo was quite certain his own home would never be in Rome.

Leonardo crossed the bridge to the Vatican one more time, cringing at another visit with Cesare Borgia or Pope Alexander. But the younger Borgia had promised him the use of a fine horse for his trip back to Florence, and for that luxury he could endure one more visit with father and son. As long as Borgia didn't renege on his offer, Leonardo should be able to be on the road and out of the city with enough time to make it to Viterbo. He hadn't been to the city before, but during their tours of Rome Bramante had told him much about the medieval walls and the ancient gates there that differed so much from what they had seen in Rome. As much of a hurry as he was to get back to Florence, there was no reason he couldn't do a little more sightseeing along the way.

Several hours later Leonardo was finally making his way north from Rome. He reached down to pat the magnificent steed he was riding. He was surprised once again at the generosity of his employer, or actually, now, more properly, his former employer. For his trip back to Florence, Borgia had indeed provided him with one of the best horses Leonardo had seen during his nine months of employment as his military advisor.

Before this unexpected trip to Rome, Leonardo had actually expected to be walking back to Florence once he was unemployed again. But in a rare moment of generosity Borgia had insisted, indicating that he would have someone else retrieve the horse on a future trip to Florence. Leonardo was not sure the Florentine City Fathers would like to hear that particular portion of his news, but that was not his concern at the moment. He had done what he could do for them in nine months of travels with and for Borgia. Surely they could expect nothing more.

<center>***</center>

Leonardo's stop in Viterbo was intentionally brief. After spending the night at an inn located just outside the walled center of the city, he had wandered through the ancient gates into a city that reminded him of none that he had ever seen before. The external staircases that seemed to be on the outside of every building, home or otherwise, fascinated him. He stopped to sketch several of them as he made his way to the Palace of the Popes. He could see the irony in taking the time to stop at one of the many summer homes popes had built through the centuries when he had just escaped the home of a pope. But this was different – it was history and it was unique architecture – two good reasons to take a brief look around.

Before exiting the medieval walls that surrounded the city Leonardo enjoyed one last look at the ancient ruins peeking out from under several newer buildings. In that way, Viterbo was not so unlike Rome.

Once outside the walls and away from the narrow cobblestone streets, Leonardo mounted his horse and continued his way northward, happy to be one day closer to home. He enjoyed the feel of a good horse under him once again. It reminded him of the marvelous war horses the Duke had once owned in Milan.

As he rode, Leonardo enjoyed the changing landscapes ahead and around him. He was actually anxious now to return to a studio and begin painting again. As the sun rose higher, he realized he hadn't thought much about where he would stop each night as he headed home, beyond that first night at Viterbo. Had Salai and Tommaso still been with him, they would have been more worried, but it would actually have been less of a concern. But traveling alone like he was now, he needed to be careful. He was no longer under the protection of Borgia and his troops and it would do him no good to survive nine months of employment with Borgia only to be attacked as he rode for home. He still had his pass from Borgia but he was confident he would soon be beyond the regions where that would assure him of any protection.

As his second day of riding was drawing quickly to a dark closure he was relieved to see the top of a building that appeared to be a monastery. Here he would not drop the name of Cesare Borgia, no, here he would rely on his connections to Fra. Luca Pacioli instead. Leonardo wrapped his cloak tighter around him, finally noticing that the evening air had cooled significantly. *Yes, a quiet night at the monastery would be just the thing.*

Leonardo enjoyed the next two days of his journey, appreciating the changing scenery as he continued his trek north, occasionally even stopping to sketch some of what he was seeing. The thought of holding a paintbrush in his hand again was certainly starting to excite him. Maybe his time away with Borgia had accomplished something positive – rekindling his desire to paint, not just for the money it might bring him in commissions, but also for the enjoyment it would bring him.

<center>***</center>

Only once on the way north did Leonardo choose to sleep under the stars instead of seeking shelter for the night. Just as he was starting to consider his options he came upon several families who were traveling together on the road. He had slowed his pace to converse with members of the small group. As the day had been warmer than usual that day, the evening air had not been particularly cool. The families had found an open area near the road and decided that they could safely stop there for the night. Apparently judging Leonardo to be no threat, they invited him to join them, and he gratefully agreed. He had frequented enough inns and monasteries for this one short trip and was grateful to be able to sleep under the stars on such a beautiful night.

Leonardo secured his horse nearby, brushing him quickly and giving him some food to nibble on and then joined the adults around the campfire. Only as one of the men pulled out a lute did Leonardo regret not having brought an instrument of his own along. *Oh yes,* he thought, *that would have gone over well with Master Borgia. He could just imagine himself saying, 'Yes, I realize you told me to pack light, but I thought the addition of my instrument to be worthy of the space it would take up.' No, that wouldn't have worked at all.*

Leonardo had been deep in his own thoughts and hadn't realized the man was looking at him, apparently reading the disappointment in his face that he hadn't realized was there. "Do you play, Master Leonardo? I would be quite content to listen rather than to play myself."

Leonardo nodded his head and accepted the instrument carefully. "I have only played a bit in the last many months, but yes, I have been known to play a lute now and again."

Soon the entire group was laughing and singing, and Leonardo was enjoying the music making immensely.

Chapter Seven
Salai and Tommaso - Florence
March 1503

Salai and Tommaso had been working to set up Leonardo's studio the best they could. They were confident he would find much fault with their efforts when he returned, but at least it was a start. In the midst of their cleaning and stacking, a messenger arrived to inform them that Master Leonardo's books were being delivered shortly from the Santa Maria Novella monastery. Would they be available to take possession of the large chests?

As they unpacked the books, Tommaso frowned. "I had forgotten how many books the Master left behind when we headed out last year to work for Borgia. What are we going to do with all these?"

Salai shrugged. "We just need to arrange them neatly against that wall. The Master can decide for himself how he wants them."

That task completed, the two young men stepped back to look at the long line of books they had arranged along the wall.

"I'm bored, Salai, let's count the books the Master has here. At least it will keep us busy for a little while and keep our minds off what is taking the master so long to come back to Florence."

Salai groaned. "Count? Just for the fun of it? Whatever for? And you are too big a worry wart, Tommaso, do you know that? The Master will come back to us just as he said he would." But even as Salai was

speaking he had moved to the end of the wall furthest from Tommaso. "I'll start counting at this end, and you start at your end. Let's see if we can meet in the middle."

Tommaso smiled, glad his friend had agreed. Moments later they were both standing in the middle of the long row of books. "I counted 53, Salai, how many did you count?"

"I guess we did find the middle. I counted 53 also."

"I didn't know the master owned over 100 books, did you?"

Salai shook his head. "I knew there was a large number of them again, but I wouldn't have guessed there were this many. He had accumulated over 100 volumes when we lived in Milan. But he had to leave so many of those behind when we fled from the French that I wouldn't have guessed he had managed to collect so many already."

Tommaso walked back and forth in front of the wall. "I don't know why we should be surprised. When money is tight and food is getting scarce, the master still always seems to have enough to buy a new book."

"I'm fairly sure he buys a new one almost every week, at least when we're somewhere safe. I don't think he bought very many while we've been traveling with Borgia and his army.

"Not many, but we did have to bring a few new volumes back to Florence with us. I'm glad most of these were waiting here for us instead of with us."

Salai nodded his head in agreement. "Now that we've counted the books, do you think we should try to arrange them for the Master? I would certainly rather arrange them than read any of them."

"Do you think we even could read them, Salai? I can't read Latin, can you?"

Salai looked around to be sure no one else was listening, even though the two young men were the only ones in the studio. "Want to know a secret? The Master can't read Latin either, at least not very well. Most of these books are in Italian. The Master generally waits until a book he wants has been translated into Italian before he buys it."

Tommaso looked shocked. "Are you sure?" he asked in disbelief. "I thought I had seen him make lists of Latin words in his notebooks before. Or maybe they were Greek, none of it would make any sense to me."

"They were Latin vocabulary words. He's been working on Latin for many years, since the first time he lived in Florence, I believe. He does know more than we do, certainly. And I may have been wrong, a few of these might be in Latin, if he couldn't wait for them to be translated. But I've heard him express frustration more than once at how bad his Latin is. It's one of the reasons he doesn't consider himself a learned man."

Tommaso almost knocked over the chair he had started leaning on. "Master Leonardo not a learned man, who would say such a thing? He's the smartest man around."

Salai agreed. "Oh, you don't have to tell me. But since he wasn't going to be allowed to attend University, he was never taught Latin as a young boy. Or much else from what I understand. A priest in Vinci taught him how to read Italian and how to do basic mathematics. That's all the schooling he's ever had. And I've heard him complain about it more than once."

Tommaso scowled. "He should go to University – and be their teacher. What does Fra. Pacioli know that makes him qualified to be a teacher and not our master?"

"You don't have to tell me, Tommaso. I agree with you. And I don't think it bothers the master very often. Just

51

once in a while someone will say something and I can tell it gets him thinking."

"Humph. That just makes me angry. So, do you want to arrange his books or not? Maybe that will make him happy when he arrives back from his long journey from Rome."

"But I don't know how the Master would want them arranged. Do you think he would arrange them by color, or size, or title, or what?"

"I don't think he would arrange them any of those ways, though I have to admit I've never paid much attention. Why don't we try to alphabetize them for him? But I don't think we want to do that by title. How about by author?"

"Sure, let's give it a try. If we get tired before we finish, we won't tell him about it! There's a book by Vitruvius here in the middle. I'll take that down to the end I started from. That has to be one of the last books. And here's a book by Alberti, that has to be one of the first books, so you can take it down to where you started."

"Livy's *History of Rome* would go somewhere in the middle, but where would we put the grammar books and these easy arithmetic books?"

"Good question. If there's no author listed, let's put them at the far end right after Vitruvius. That seems as good a place as anywhere. And here, Tommaso, you can put this book of military inventions down there by Vitruvius, too. It looks like it was written by someone else who's name started with a V."

"Do you think he actually reads any of these Salai?"

"Of course, look how worn some of them are. I've seen him refer to Vitruvius often. And Pliny's book on Natural History is one of his favorites."

"Okay, if you say so. I don't think I want to know this much about anything. Oh wait, here's two copies of

Aesop's Fables; they probably go at the very beginning. I'll put both of these at that end just before Alberti. Have you ever read any of *Aesop's Fables*, Salai? Now, those I like. They're funny."

"Oh yes, I like them, too. Some of the master's short stories remind me of *Aesop's Fables*."

"Do you think when we're finished it would be okay for us to read through one of those books? If we're really careful?"

"I don't think the master will mind if we don't mess it up. Let's see how quickly we can do this. Here's a copy of Euclid, Tommaso, it would go more your direction."

"Euclid? I think that's one of the books the master has been studying most recently. What's it about?"

"Something to do with mathematics. Geometry, I think I've heard him say. But it isn't just a recent study. He's been studying Euclid for many years now. In fact, I think Pacioli was teaching him about Geometry from it when we all lived in Milan."

"That's funny, here's a copy of the book Pacioli wrote on Geometry."

Salai almost dropped the book he had been trying to put away and then rushed over to where Tommaso was standing. "Can I see it? I want to see if that's the one the master's drawings are in."

Both young men lost interest in their alphabetizing as they carefully flipped through the book, admiring the carefully drawn geometric shapes throughout it.

Salai smiled warmly. "That's the first book to be published with Master Leonardo's artwork in it. Someday I think there will be many more. He's been working on his notes for many other books that he wants to write himself."

"I like the Master's work. That would be good. Let's see how quickly we can finish this task, and then read Aesop's Fables together. We can take turns."

Salai nodded and they went back to work, carefully trying to arrange the long row of books in order. It wasn't until they finished the work and sat down to look at Aesop's Fables that either of them realized that the book of fables they had picked up was in French.

Chapter Eight
Machiavelli - Florence

June 1503

Leonardo was still more than a little annoyed with Machiavelli for his part in getting him the assignment the previous year as military advisor to the ruthless Cesare Borgia, but he had to admit that the nine months or so he had worked for him hadn't been all bad.

The job had given him plenty of opportunities to sketch – to sketch the people he encountered, as well as the various plants and unique buildings he came across, as he traveled across the peninsula with Borgia's army. And of course, there were the military weapons and machines he had designed for Borgia. Those he still had mixed feelings about. Was it right to design something whose primary purpose was destruction, and often the destruction of life? No, he could be happier with the maps he had made while in Borgia's employ, particularly his map of Imola. That had to be one of his brightest moments.

Certainly better to focus on the positive things I was able to accomplish, he concluded.

Leonardo had heard recently that Machiavelli was back in Florence again and tried once more to convince himself that he hadn't been avoiding him. *But no, if I'm honest with myself, I have to admit that I have been trying to avoid seeing him, at least a bit. He's still too strongly connected to the bad portions of working for Borgia.*

Looking down at the notebook on his lap, Leonardo realized he had absent-mindedly drawn another military

55

apparatus while he was talking to himself. Studying his sketch intently, he wondered which portion of his mind had produced it. Deep in thought again, Leonardo was still only slightly surprised when Machiavelli picked that moment to come strolling through his studio door.

"I see you have returned safely to Florence," Machiavelli stated quietly.

"I have indeed. And I see you have as well. I hope you do not bring news of another dangerous mission the City Fathers would like me to undertake for them."

"No, they have not sent me to you this time. In fact, I was rather thinking this time that you and I should approach them." Machiavelli paused and Leonardo waited for him to go on, having no intention of giving Machiavelli the satisfaction of either a question or an answer from him.

"Don't you want to know what I have in mind, Leonardo?" Machiavelli finally asked, sounding genuinely offended that the older man had not asked.

"No, as a matter of fact, I do not. I'm fairly sure it was your suggestion to the City Fathers that I go play military advisor to Cesare Borgia. Why would I want to know what other trouble you are trying to bring my direction?"

Machiavelli pouted before answering the question with his own questions. "Now, Leonardo are you telling me that you didn't enjoy your time as Borgia's advisor? Keeping an eye on him on behalf of the Florentine government? At least you didn't get deathly ill while you were working for him like I did."

Leonardo snorted. "I did not hate every moment of my time as military advisor to Borgia. But after serving in that role for the Duke of Milan, for the city of Venice, and now for the Pope's dangerous son, Cesare Borgia, I am ready to retire from such roles."

This time Machiavelli just laughed.

"So what is it this time, Machiavelli? Though if I had any sense at all, I wouldn't even let you tell me."

Machiavelli started, "You know how Florence and Pisa are at war again?"

Before Machiavelli could continue, Leonardo abruptly turned around. With his right arm he pointed toward the door. "Out, Machiavelli, out. I already told you I wanted no more to do with war."

Machiavelli moved slowly towards the door, hoping Leonardo would let him finish explaining. "But, this is different, we're going to work together to put an end to the fighting. Would you at least let me explain?"

Leonardo turned around, still fuming at Machiavelli's initial comments. "Well, speak quickly then. You're interrupting my work."

Machiavelli began again, trying to get to his point as fast as he could. "You and I can divert the Arno River. You've been working on plans for that type of thing for years now, I've seen them. If we divert the river to bypass Pisa, Florence will finally gain its complete independence from their conniving ways. They would lose their ability to interfere with our water supplies, we would have easier, direct access to the sea, and we could finally give Pisans and Florentines reason to stop fighting. As the Florentine Secretary of War, I can make that happen. And the first thing I want to do is to appoint you as my Strategic Engineer."

Stopping to catch his breath, Machiavelli looked back toward Leonardo cautiously, afraid of what he would see. Much to his relief Leonardo had stopped scowling and almost seemed to be contemplating Machiavelli's suggestions.

Then, without uttering another word, Leonardo turned his back on Machiavelli again. For a moment, Machiavelli wondered if Leonardo was still angry, but then

realized he was moving quickly to a large stack of notebooks on the floor in a corner. "Well, don't just stand there, Machiavelli, come over here and help me go through these. If we're going to talk about my old plans I want to see them again."

Machiavelli quickly joined Leonardo in the corner, stooping down to pick up the first notebook. He had seen Leonardo writing in his notebooks almost every time he had been with him, but he had never actually flipped through any of his pages. Turning the first few pages of the first notebook in front of him, Machiavelli was stunned. In fact, he had difficulty continuing to turn the pages. Each page had something that caught his eye, that required his longer attention – a life size leaf that looked like he should be able to pick it up off the page, surrounded by the backwards writing that he had long recognized as Leonardo's, followed by another fierce looking military machine which he hoped never fell into the hands of the likes of Cesare Borgia. Sensing Leonardo's impatience for getting through the notebooks, Machiavelli forced himself to turn the pages faster than he wanted to, wondering if he would even recognize what Leonardo was looking for if he saw it. Several pages into the notebook he was holding, Machiavelli came across facing pages that were completely covered with dozens of small sketches of arches that were each accompanied by an even smaller amount of writing.

Leonardo glanced at the pages open in Machiavelli's lap. "I see you have found the arches I sketched while I was in Rome. I saw so many arches there, that I was compelled to make a brief study of arches. That was one of my favorite parts of being in Rome – seeing their marvelous use of the arch. But, that will not help us with the project at hand. Please continue looking for the studies related to water."

Machiavelli nodded, trying again to turn the pages at a faster pace. But only a few pages later, he found himself staring at stunning architectural plans. Again the temptation was so strong to just stay on the pages he was looking at, wanting desperately to know what Leonardo had been working on there. Only when Machiavelli heard Leonardo drop a notebook onto a new stack on the floor did he realize that Leonardo was looking through his third or fourth notebook while Machiavelli was still holding the first one he had picked up.

This is no way to get this project started, thought Machiavelli, *getting Leonardo annoyed at me right from the beginning.* With that, he forced himself to turn the pages quicker, trying to find something connected to the water in rivers, while not allowing himself to be further distracted. Just as he was coming to the end of his first notebook, Machiavelli noticed the word "currents" scribbled sideways toward the margins. It looked like a thought had been hastily added next to a list of Latin words. Vocabulary words, he wondered?

Machiavelli cleared his throat and turned the book so that Leonardo might be able to better read the quote written there. Even as he did so, Machiavelli laughed to himself. Leonardo read and wrote backwards, why would he assume that he couldn't also read upside down?

Leonardo carefully laid down the notebook he had been examining, sliding another notebook over the corner of the page to hold his place. Looking at the writing Machiavelli pointed at, Leonardo read his own words aloud, "As much as you increase the river by in breadth, by the same amount will you diminish the speed of its course."

Leonardo nodded his approval. "That's part of what I was looking for. Please mark that spot and keep looking. I know I have more about what we would need to do from

my work with hydraulics whilst I was working for the Duke of Milan."

"Yes, I do remember hearing of your work for the Duke. It was one of the reasons I was sure you could handle this task – your experience there with digging canals and your expert use of an Archimedes screw to move water."

Leonardo smiled in appreciation of Machiavelli's knowledge of his work. *Sometimes I have wondered if anyone was paying attention to all that I was doing while I was in Milan,* he thought, *even the Duke.*

Both men continued their search until Leonardo ran across another one of his related entries. He read it aloud to Machiavelli, "When mountains collapse headlong into the depths of a valley they will dam up the swollen waters of the river. Soon breached, the river will burst the dam and gush out in high waves."

Leonardo pointed at the drawing on the next page. "I wrote that and made the sketch after watching a natural flood, but both principles will also help us if we want to redirect the Arno. Let's get a notebook with some blank pages and sketch out what you were thinking about. And when we're done here, I'm going to need to start mapping the relevant areas as soon as possible. But I'm warning you, Machiavelli, the first time it appears that you are using the idea of a Strategic Engineer to cover up the fact that what you were really looking for was a Military Advisor, will be the last time I help you with any of this."

Chapter Nine

Arno River

June 1503

By the time Machiavelli had come to discuss matters with Leonardo, the Florentine troops had moved within five miles of Pisa. Machiavelli had heard rumors that Pisa was asking Cesare Borgia for his assistance in their fight against the Florentines, and he was praying that the rumors were not true. He and Leonardo were going to have to get to work quickly, especially since Borgia was known for his ability to arrive in one place before it was even known that he had departed from his last location; an ability that would certainly not work in the favor of the Florentines.

Machiavelli had just received the good news that his troops had taken possession of the fortress of Verrucole. His first task would be to get Leonardo out to the fortress for an examination – without his old friend feeling deceived. If Leonardo thought he was being tricked into taking on the role of Military Advisor again, Machiavelli was quite sure Leonardo would follow through with his threat to desert their project. But he really needed Leonardo to come out into the field with him to examine the fortress and the camp of soldiers in and around the hilltop and give his expert opinion.

As the two men made their way out to the Fortress, Machiavelli could see that his old friend was in a good mood. He hoped that would remain the case. As they travelled together, Machiavelli shared with him some of his

recent experiences as the head of the Florentine militia. "I do not want to have to hire mercenaries, Leonardo. We should be able to defend our city with our own citizen army."

Leonardo looked out the windows of the carriage as they travelled. Machiavelli wasn't sure whether he was listening, but continued on, in hopes that he was. "This has been such a long struggle between us and Pisa. My dream is to see the true independence of Florence in my lifetime."

As their tour around the fortress continued, Machiavelli finally started to see excitement in Leonardo's eyes. *For all his complaints about not wanting to be a Military Advisor,* Machiavelli thought, *he is so very good at this job.*

After a thorough examination, Leonardo declared the fortress to be satisfactory, but was quickly sketching out ideas to improve upon it. "This should make it impregnable, even against the most serious of threats," he explained to Machiavelli as he demonstrated his ideas to him with enthusiasm. "Now let's continue our exploration of the area. I really must start mapping the Arno River and the countryside around it, if we are to determine the proper way to divert it."

Chapter Ten
Mona Lisa - Florence
July 1503

Tommaso and Salai rushed into the studio, looking anxiously for their master. They weren't sure how he would take the news of the visitor – anymore they never knew how he would take specific news. Both young men stopped abruptly in front of Leonardo's work bench, at once fascinated by the tinkering he was doing, but at the same time, both acutely aware it would not pay any bills. Salai looked at Tommaso, hoping he would speak first, but Tommaso shook his head, making it quite clear that Salai would have to be the one to speak. Salai cleared his throat, hoping the Master would look up. But Leonardo continued working on the experiment in front of him.

Tommaso elbowed Salai, who finally blurted out, "Master, you have a visitor in the front room."

Salai paused and waited for Leonardo to respond, but he continued working as if Salai had not uttered a word. Tommaso finally spoke up, "Master, he spoke of a commission – of work that he would pay you for."

At first both young men thought Leonardo was not going to answer them, but he finally turned away from the table and looked at them. "A commission for what?" he finally asked.

Salai and Tommaso practically climbed over each other to share the good news. "A portrait," Tommaso quickly exclaimed.

"Of a woman," Salai added.

"Of his wife," Tommaso said, adding "Please come speak with him, Master, before he changes his mind and goes to someone else."

Leonardo brushed his hands on his apron before taking it off and carefully laying across a nearby chair. "Come along gentlemen, let's see what our new patron is like."

Salai and Tommaso both broke out in a run and raced towards the adjacent room. Leonardo whistled as he followed them. *A portrait,* he thought. *Yes, he could definitely be convinced to paint another portrait now. It had most definitely been too long.*

Leonardo entered the front room a few minutes behind the younger two. He was pleased to see a distinguished-looking older man looking at some of the sketches Leonardo had hung around the room.

"Ah, Master Leonardo, I am Ser Francesco del Giocondo. I was just admiring your work. Even without paint, your pictures seem to come alive."

Leonardo smiled his appreciation and showed the older gentleman to two nearby seats.

"I hear you would like to have a portrait done, Master Giocondo."

"Yes, Master Leonardo, most certainly. I have had business dealings with your father for many years and he assures me that you would do an outstanding job on the portrait I desire."

Leonardo tried not to react visibly to the mention of his father. He would not have expected his father to recommend his work to anyone, especially since, as far as Leonardo knew, his father had seen very little of it.

Master Giocondo continued, apparently without noticing Leonardo's discomfort. "My wife Elisabeta has borne me a lovely child this spring, our third, in fact. And after living in an apartment we are finally moving into a

much larger home. A portrait of her to grace our wall would be a perfect way to celebrate both. How soon would you be able to start it? How soon would you be able to complete it?"

Leonardo smiled inwardly, noticing that the gentleman had not asked about his prices. He had assumed that his new patron-to-be was a merchant, and this line of questioning fairly well confirmed that.

He responded carefully, "As far as beginning, Master Giocando, I can begin the preparatory sketches almost immediately. We can schedule a good time for your wife to come to the studio, or I can bring my supplies to your home, whichever you prefer."

Master Giocando nodded his head in satisfaction, and then Leonardo continued, "As far as a completion date, that would be much more difficult to predict. Portraits take a long time to complete when done right and I must work on them around my other commissions."

Leonardo thought he heard snickering from the corner where Salai and Tommaso had last been seen. He would have to scold them later about their bad manners.

Leonardo waited to see if his unwillingness to be tied down to a completion date would be the end of this conversation, but he knew from too much experience how difficult a patron could be if their expectations did not meet his.

Master Giocondo seemed to consider the matter only briefly before putting out his hand to Leonardo. "Please have a contract drawn up with your particulars for fees, approximate timing, etc. Have it sent to my home by the end of this week, and I will have Lisa and one of her servants come to you at this time next week, if that is quite convenient. Since we are in the middle of a move, our home is hardly a suitable place to work, as I'm sure you can imagine."

With that Master Giocondo was on his feet and heading outside. As soon as the door closed behind him, Leonardo turned to find the boys. "Tommaso, Salai, come here this instant."

At first there was no answer and Leonardo considered yelling again. But before he could, the two of them were walking sheepishly towards him.

"Yes, Master," Tommaso mumbled. Both young men were trembling.

Leonardo looked at the two of them, started to say something, and then abruptly turned around and headed to his work bench, leaving the two of them standing there.

Tommaso looked as if he would cry until Salai started laughing. "What's so funny?" he demanded.

"The Master was going to yell at us for snickering earlier."

Tommaso looked questioningly at his friend. "I don't see how that's funny."

Salai was still laughing when he finally got out his answer. "He couldn't yell at us because it was true."

Tommaso was confused. "What was true?"

"The reason we were snickering. The Master doesn't have any other commissions right now. He was using that as an excuse for how long he will take on the portrait. He was mad at us for laughing during his conversation, but he really couldn't say anything to us."

Slowly Tommaso started to relax. "So you don't think we're going to be in trouble?"

"No, of course not. Our Master is too much a man of honor to stay angry at us for long over the truth. That's why he walked away so quickly just now. He couldn't face us."

Tommaso was still not completely convinced, but he managed to calm down further.

Salai grabbed him. "Let's go up in the rafters and spy on the Master in his workroom. I want to see more of whatever scientific experiment he's working on today."

With that Tommaso managed a smile. "But we'll have to be very quiet. Otherwise we will really be in trouble!"

Chapter Eleven
Mona Lisa - Florence

July 1503

Lisa showed up the following week at the appointed time, accompanied by a young servant. Leonardo showed Lisa to a chair situated by a window with good light and the servant quietly took a chair across the room where she was out of the way but had a good view of all that went on in this portion of Leonardo's studio.

As Lisa sat carefully in the chair, she looked at Leonardo with amusement before speaking. "I'm sure you are accustomed to painting portraits of women who are much younger and much more beautiful."

Leonardo was surprised at her comment and for a moment found himself at a loss for words, something that was seldom a problem for him. He struggled to think of something, but was almost certain there was nothing he could say that would come out correctly. But soon he had regained his composure. "There has been no shortage of women who sat before me who were adorned with more jewels and fancier dresses than what you have chosen to wear, but it could better be said that you have no need of such things."

Lisa smiled, a simple smile, that Leonardo quickly hoped he would be able to capture in her portrait. She turned her head more towards him, as if trying to decide whether he was simply being nice. "Since my husband is a silk merchant he had suggested I wear a more elaborate dress, but this green velvet is one of my favorites. And I

didn't think a necklace was necessary with it. Was I correct or incorrect, Master Leonardo?"

As Leonardo set up his easel at the right angle to be able to sketch her well, he considered her newest question and the appropriate response. "You have chosen quite well, Madam Lisa. I will be very happy to sketch you as you are."

Leonardo started sketching almost immediately, wanting to get a good starting point for the portrait that was beginning to form in his mind. *Yes, a simple wardrobe will do quite nicely,* he thought, *it will compliment a more complicated landscape I can do for the background.*

For quite a while the conversation hung in the air around them, like an unfinished meal. It was there if either of them wanted to pick it up again, but she seemed content to sit quietly while he worked.

After forty-five minutes or so of sketching Leonardo remembered the request to keep the sessions to no more than an hour. He placed his piece of charcoal on the table next to him and wiped his hands on his apron. "I am at a good stopping point, Madam Lisa, and I know being done on time is important to you. Shall we say the same time next week?"

Lisa stood, smiling appreciatively. "Yes, barring family emergencies, we can certainly plan to be here at that time."

Before Leonardo was even aware that she had stood up, Lisa's servant had crossed in front of him and headed to open the door of the studio for her mistress. As the two women exited, Leonardo was once again excited about painting a portrait. *I will show the motions of the mind,* he told himself, *and true movement, even as I did with the Last Supper. I will prove once again that movement can be shown in a painting.*

In fact, he mused, *I will show that painting is the true daughter of nature. It is superior to poetry, because it can instantly be understood. And it is superior to music, as wonderful as music can be, because it does not immediately perish after it has been created. No, painting is truly superior to those and sculpture, and all that see my finished portrait will have no doubt of that fact.*

Chapter Twelve
Arno River

July 1503

Over the next several weeks, Leonardo and Machiavelli made numerous trips out to see the Arno. In spite of his regular sessions with Lisa and his work on her portrait, Leonardo still managed to set aside a fair amount of time for his work on the Arno River.

Machiavelli was relieved that Leonardo appeared to no longer suspect him of tricking him into doing a job he didn't want to do. Instead Leonardo seemed quite content to draw and discuss, telling Machiavelli on one of their outings, "I have been experimenting in my workshop, to add to the knowledge I obtain from my observations here in the field. It is quite clear that the flow of a small river can be changed with a large stone. But the question still remains how we can best divert a large river."

After many hours of riding through the countryside, the two men stopped for a quick break and Leonardo opened his notebook to show Machiavelli some of what he had been working on.

"I made a ride out closer to Pisa last week so that I could draw up this rough map of how the river actually approaches the city. That information will be quite important when we determine exactly where to do our digging. You can see here that I have marked the towns and forts that are closest to the river between us and Pisa. We will need that information as well, in order to protect our workers."

71

Machiavelli studied the maps and other sketches that his friend had made. He wondered at how much Leonardo had managed to accomplish in such a short amount of time. *Sometimes I wish I had been given the gift of drawing like Leonardo has,* he thought, *but no, my gift is more in the area of writing. That is where I need to focus my energies, and leave the sketching to men like Leonardo.*

Leonardo continued explaining the notes and sketches he had made. "Here you can see the effects of boulders piled into a river bed. I observed them closely on one of my rides and sketched the effects I was seeing. Notice how the flow of the river changes around the boulders. We will have to keep all of these things in mind when we begin to work."

Machiavelli nodded his approval. "I think it is time for us to present our plan to Master Soderini and the rest of the City Fathers. Could you please make a detailed map that includes all of the pertinent details, that will show them what we will be dealing with? How long would you need to finish such a map and when would you be available to meet with them? I have an appointment with Soderini later today and will set up a meeting time for us. We have had Pisa under siege now for some time and I know they are interested in bringing this war to an end."

Leonardo had tried not to think of the effects of the siege on the people living in Pisa. He was well aware that sieges could be an effective way to bring a city to its knees without the same type of bloodshed that outright fighting would necessitate. But it still troubled him to think of civilians, particularly the very young and the very old, who were most likely suffering as a result of the siege. *War is madness,* he thought again, *in whatever form it presents itself.*

"You may set the meeting up for the end of next week, Machiavelli. I should have the map done by then. If we are going to take on this project, it really needs to be during the summer months while the weather is somewhat milder and the workers are able to accomplish the required amount of digging."

<center>***</center>

Leonardo soon found himself in the Florentine City Hall in front of an assembly of the City Fathers. As he laid out the map that Machiavelli had requested from him, he addressed the group. "You may all see the Arno River here in the vicinity of Pisa. I have included all of their existing canals, as well as all of the fortresses in the area that the Florentine army will need to be aware of."

He moved his hand to another portion of the large, carefully colored map and pointed out his plan. "Here you can see the canal that I am proposing be dug from the west side of Cascina to connect the Arno River with the Stagno River. This canal will accomplish your desire of diverting the Arno River and cutting Pisa off from it. From the perspective of the Pisans, we will effectively be leveling the Arno."

Leonardo paused to see if there were questions, knowing full well that the gentlemen in front of him would have no end to questions. Sure enough the questions came at him quickly, one right after the other, before he could answer any of them.

"How many laborers will this require?" one of them asked him.

"What will be our cost of doing this?" another demanded.

"And how do we know this will work?" a third man inquired of him.

Leonardo smiled and pulled out his ever present notebook. Putting up his hand for the questions to cease,

he read from his notes. "We can put 2,000 laborers to work at a time. And of course they will need soldiers to protect them. I have calculated the amount of dirt they will each be able to dig in a day, as well as the amount of dirt that the entire project will require. I believe you will find the total cost for their labor and my consulting services to be quite reasonable, especially if it finally brings this war to an end."

With his answers came a new set of questions followed by discussion between the City Fathers sitting closest to each other. Leonardo interrupted them once again. "If you have no further questions for me at this time, I will be returning to my studio and allow you to discuss my proposal. You will know where to find me if my services are required further. I have enjoyed the opportunity to draw the very landscape that I first drew many, many years ago as a young man. And I thank you for that opportunity. But I have a studio to run and mouths to feed, so this will be the end of our discussion unless you choose to hire me. Good day, gentlemen."

With that Leonardo carefully but quickly rolled up the map he had brought and tucked his notebook back under his belt. Nodding at the speechless Machiavelli, he exited the room, wondering if the enjoyment he had had of being back on a horse and riding though the countryside would be the sum total of the payment he would receive for his work from the last several weeks. *Well, if so, I guess it serves me right for working without a contract from them*, he chided himself as he headed back towards his studio. But he had a portrait to keep him busy if the City Fathers had no further need of his services.

<center>***</center>

Leonardo was bent over his worktable studying the flow of water in yet another of his seemingly endless experiments when Tommaso came rushing into the room.

"Master, Master Machiavelli is here to see you again. Shall I show him in?"

Before Leonardo could answer him, Machiavelli had pushed past Tommaso and headed towards Leonardo with a purse of jingling coins in his outstretched hand. "Don't be silly, Tommaso, of course he wants to see me. I come bearing money and a contract from the City Fathers. Your master has been hired to level the Arno."

For a moment Leonardo ignored both Machiavelli's comment and his presence. Finally looking up from his work, he asked his friend, "So have you ever thought of how similar water and air behave?"

Machiavelli shook his head as he wondered if Leonardo had even heard his comment about the Arno River.

Chapter Thirteen
Battle Painting - Florence
October 1503

Machiavelli had shown up at Leonardo's studio unannounced yet again. He was beginning to think he would wear a path in the streets between his own office and Leonardo's studio. He had expected to find Leonardo bent over a table studying the flow of water again. But instead he was sketching in a large notebook. As Machiavelli approached he could see more sketches of canal locks on one side and what looked like an oversized digging crane on the other. *Apparently Leonardo has been working on the Arno Project more than I realized,* Machiavelli told himself.

The scowl on Leonardo's face told Machiavelli that his arrival was not appreciated, but Machiavelli had come to expect little else.

"Well, good morning to you, too."

"With what undesired news do you interrupt me this time, Machiavelli? It seems that your presence always serves to distract me from my work, and oftentimes puts my life or the lives of others at risk. Is that what your job as Military Strategist for the City Fathers requires of you, Machiavelli, or is it some dark thing deep within your soul?"

"It would be the former for certain, Leonardo, though the latter may affect it also. I do come with news from the City Fathers."

Leonardo groaned, certain that he would not be interested in whatever news they were sending his way this time. "I have done my part for the city, Machiavelli, you may go back and tell them that for me. Short of giving my

life, I have done as much or more than all the citizen soldiers you have been training to protect the city. For several months now I have been working on diverting the Arno River. Every time I turn around they are doing something to get in my way there. Sometimes it is a budget cut, sometimes it's simply disagreeing with my scientific observations on how best to cut the canals and change the path of the water."

Machiavelli stood quietly, enduring his friend's frustrated words. "And before that I gave up almost a year of my life in their service, most of it in the company of the most ruthless man in the world. Even if Cesare Borgia himself is barking at the city gates, you may tell them that I will finish this current project, but when this is done, that is all I intend to do for this city." And with that Leonardo turned his attention back to the water that had been flowing across his table.

Machiavelli waited to see if there were any more words waiting to be fired his direction. Then he cleared his throat and began quickly, knowing that at any moment Leonardo could once again show him to the door. "It is related to our war with Pisa, but it's a different type of commission this time. The City Fathers want to hire you to paint a very large fresco in the Big Room of the 500, or the Great Hall as you have probably heard it called. As you know it was expanded recently and has never been properly decorated. A battle scene that will inspire all who see it will be the perfect way to showcase the large eastern wall there."

Leonardo actually stopped what he was doing and looked up at Machiavelli as if he was considering his answer very carefully. He didn't speak right away, so Machiavelli continued, "Your portrait of Madam Lisa has been causing such a stir that Soderini is convinced you are just the artist to take on this commission. We need citizens

77

and city leaders alike to remember the victories we've had in the past, to keep their spirits up in this extended conflict with Pisa."

Leonardo hadn't said absolutely not yet, so Machiavelli pressed on, "They are already working on the contract. I think you will be quite pleased with it. It is a much more generous contract than the one they gave you for diverting the Arno River. This time they will be giving you a monthly allowance, plus expenses for your materials, and they have arranged to give you studio and living space at the Santa Maria Novella. It will be larger than the space you have here, and closer to the City Hall."

Leonardo was clearly considering the offer very seriously. "So what portion of the contract won't I like, Machiavelli?"

Machiavelli smiled slightly. He should have known it couldn't be quite that easy. "Well, you know they will have expectations about how long the project should take from start to finish. I believe they have a very reasonable fifteen months in mind for you to be started with the painting."

Leonardo frowned. "Go on. What else?"

"Well, they have specified the battle they want you to paint. The Battle of Anghiari, the Florentine victory over Milan. And that really is it. I think the terms are ones you should be able to work with." Machiavelli looked around conspiratorially before continuing, "And if you need more time to finish, I'm sure they will give it to you. As long as you are continuing to give them evidence that you are making progress, you should be fine."

Without saying another word, Leonardo put down the supplies he had been using, dried his hands on his apron, and then hung the apron across his chair. "Well, what are you waiting for? Let's go see this wall where the City Fathers want me to paint a mural."

Leonardo had ended his sentence with emphasis on the word mural. Machiavelli grinned. He had been expecting to have Leonardo react to his use of the word fresco. There might be any number of things that the City Fathers could get him to waiver on as they ironed out the last details of the contract, but expecting him to use actual fresco techniques was not one of them. Machiavelli had heard more than enough of the stories of Leonardo's slow work on the *Last Supper* in Milan. Fresco methods required speed, and that was one thing no one was going to get out of Master Leonardo!

Chapter Fourteen
Battle Painting - Florence
October 1503

Machiavelli had been right; the terms of the contract had been generally to Leonardo's liking. When they gave him the keys to his rooms at the Sala del Papa off the Santa Maria Novella, Leonardo had to admit he was excited. The space gave him privacy to work, rather than being forever close to the political center of Florence. And this space was large enough for him to work on all his different projects, it had enough room to house his growing number of assistants and apprentices, and it was all being paid for by the city of Florence. He hadn't been treated so well since Duke Ludovico had been forced to flee Milan in 1499.

Of course, the reality of the space had been a little less spectacular. He had wondered immediately when the last time anyone had lived or worked in this portion of the monastery's property. He had immediately requested that they send a carpenter to repair the roof; he didn't want to feel like he was still sleeping under the stars by the time winter really set in. He had already decided that if there wasn't massive improvement by the time he appeared at the Palazzo della Signoria to receive his next monthly allowance, he would be having very strong words with his employers. And he had already started a list for them of the extra funds he would need for paper and wood.

Leonardo stood and considered the task the city had commissioned him for. This wall in the Grand Council Hall they wanted him to paint was significantly larger than the one where he had painted the *Last Supper* mural in Milan several years earlier, almost twice as wide and more than three times as tall.

Leonardo smiled as he considered the battle they had assigned to him. The Anghiari Battle sixty years before had been a Florentine victory – a victory against their enemy to the north, the Milanese. It wasn't lost on him that they were making a point in giving him that particular assignment.

His smile turned to a frown as he thought of his decision twenty years earlier to leave Florence the first time and go to Milan. It wasn't like the Florentines had cared to keep him around then. Or even appreciated his artistic abilities enough to send him to Rome when the pope had requested artists from the Florentine Republic. But now that he had become famous in Milan, with his *Last Supper* mural and the greater-than-life-size clay model for the equestrian monument, now they wanted to claim him as one of their own. Now he was "Leonardo the Florentine," and they wanted to make sure no one, least of all him, forget it.

Leonardo shook his head. But no matter. He had accepted this commission and he would put his heart into it as he had with every other painting assignment he had ever taken on. He stood in the enormous hall looking at the wall he had just agreed to paint. He wandered slowly from one end to the other, letting his imagination play out upon the wall. In his role as military advisor to Cesare Borgia he had seen enough of war to understand its brutality. How could he best portray that here, in this larger-than-life sized space? To do justice to the soldiers that had fought? To show the horses that had fought and

died right alongside of them? As he paced the length of the room he could start to see it in his mind. He could almost hear the shouts of anger and the screams of pain. He could almost sense the snorting of the horses.

As Leonardo made his third pass in front of the large wall he was finally ready to sketch his ideas. His ever-present notebook was soon filled with horses, soldiers, and weapons.

After he had made several such sketches he moved back from the wall so that he could plan out the overall mural. He had several windows to work around – he quickly jotted them down in their approximate places. He could easily work them into his mural as bridges. Moving quickly, Leonardo's red chalk again moved across the paper. Minutes later he stopped, taking one last look at the wall and his sketches before closing his notebook, turning around, and exiting the room.

Salai and Tommaso had waited outside the building, knowing better than to disturb their master when he was planning a painting, but as he walked towards them the questions came out quickly.

"Are you ready to begin?" Tommaso asked.

"Do you want us to get more painting supplies now?" Salai added.

Tommaso started to ask yet another question when Leonardo stopped abruptly. He looked at each of them before finally saying anything. "Yes, I have begun. No, I don't need any more supplies. Yes, I am heading back to the studio, and no, I don't want you to ask me anything else."

The two young men stared at each other in surprise and then realized the Master had continued walking without them. As they ran to catch up with him, Leonardo yelled back over his shoulder, "I am going back to the studio to get some other work done. You may have the rest

of the morning off. Be back around lunch time and I'll give you each your next assignments for the day." With that he strode purposely across the square, leaving the two young men staring after him, both momentarily speechless.

"You heard him, Salai finally said. "Let's go swim in the Arno River until lunch time."

Tommaso nodded his head in agreement and the two young men took off in the opposite direction of the studio. A free morning was not something to be wasted.

Back at the studio alone Leonardo opened the notebook to the sketches he had made at the Great Hall. His pages were filling up with countless sketches that could portray the evils of war to those who had never seen it. He had once written himself a note about how best to paint a battle. He had been standing on the edge of a battlefield with some of Cesare Borgia's soldiers, witnessing the destruction of men by other men. He had noted then that an artist would need to show the smoke of the artillery combining with the dust that men and horses were throwing up all around, and to truly show the bloody mud that surrounded it all.

And now he wanted to accurately portray the anger, the fear, and even the noise of the battlefield, the terror of war. To show the men and horses of both sides interlocked in deadly combat. It was one thing positive that could come out of the war experiences he had had.

<center>***</center>

Leonardo smiled as he considered this side benefit of his commission. He now had an excuse to wander around the countryside outside the city and visit the best stables in the area. He could use the City Fathers as his excuse for studying horses again. It would be good to be back amongst such magnificent beasts, to sketch them running through their pastures. It would be less likely that he would see one rearing, or expressing the fear and

anger that the horses in his painting would need to show, but he had seen that enough in real life. Those pictures were imprinted on his memory and would make it from his mind to his chalk to his paper with only a bit of coaxing.

Before long Leonardo had filled an entire notebook with studies of horses in different positions and from different angles. *Yes,* he thought yet again, *the horse is a creature of true beauty and might.* Taking a piece of red chalk he had managed to capture one particular horse when it had momentarily looked like it was going wild. As it had reared back, shaking with fury, Leonardo had sketched hastily. *This horse will definitely star in the center portion of my mural,* Leonardo told himself as he put his notebook away and headed slowly back towards town, and towards his studio.

Chapter Fifteen
Michelangelo - Florence
January 1504

Leonardo had heard the rumors that after more than two years Michelangelo's sculpture of David was finally complete. He wondered why everyone seemed to want to bring that to his attention these days. It's not as if he had wanted the job. Sculpting was a dirty, nasty business that he had no interest in. Give him painting any day. From what he had heard the sculpture was enormous and Leonardo wondered again where the City Fathers planned to put the monstrosity. At seventeen feet in height the marble statue would tower over the city's countless other statues, though it was still nowhere near the twenty-four feet his equestrian monument was supposed to have been. Leonardo had trouble thinking about his horse monument without sadness coming to his heart. The twenty-four-foot clay model of it had been stunning, but that was all that he had ever managed to complete of the bronze sculpture.

But Leonardo knew the City Fathers were thrilled with their whole "David and Goliath" view of their city. It had been used so many times already, Leonardo wondered why no one had tired of the comparison by now. He had even posed for a much smaller bronze sculpture of David when he was Verrocchio's apprentice, and that had been more than thirty years ago. Surely it was time for Florence to discover a new image.

Leonardo had been looking forward to the next conversation with some of the older men of Florence. When they gathered on the benches on the edge of the Palazzo Spino it was a nice break from his daily responsibilities of painting and supervising the work on the Arno River. These men were his intellectual equals and they had joined him in discussions on almost as many topics as he had conversed about back in Milan.

As he joined the group, he realized they were already deep into a debate on one of the few topics that didn't really interest him – the poetry of Dante.

Leonardo sat down and one of them immediately asked him, "Well, Leonardo what do you think about this passage of Dante?"

Leonardo answered slowly, knowing that the reaction would not be good. "I realize that in Florence Dante is almost considered a local legend, but I have no real insight to add about his work. I'm sure you gentlemen were figuring it out just fine without my assistance,"

"But Leonardo, you generally have an opinion to add on anything we discuss," the speaker countered.

"Well, this is the one exception. I try not to speak harshly of one of our own, so I would rather say nothing." As he was finishing his answer, Leonardo recognized the young man strolling across the piazza just a short distance from them.

Leonardo turned to the man who had been questioning him and spoke loudly, "There is the young Michelangelo. I understand he has memorized most of Dante's work. I would imagine he would have an answer to your question."

Michelangelo slowed in front of the group as he heard Leonardo's comment. "Why don't you tell them yourself, old man? You who left Milan as a failure, never

managing to complete your bronze equestrian statue. Can you not even answer their questions about Dante?"

As the group of older men looked on in disbelief, Michelangelo turned and walked quickly away. Leonardo turned away from the group, embarrassed again by his many failures. Before any of them could add a comment in support of the older man, Leonardo had stood up, straightened his cloak, and walked just as quickly in the opposite direction.

Chapter Sixteen
Isabella - Florence
May 1504

Leonardo looked at the newest letter and frowned. He was tired of hearing from Madam Isabella d'Este and had no intention of giving in to her demands, no matter how insistent she might be. While he respected her and had enjoyed his stay in Mantua immensely, that did not mean he was forever at her beck and call. Putting the paper on his table he wondered whether Salai was around. The young man's painting ability had been improving and Leonardo had an idea. First he would have to go through his old notebooks and find one of the sketches he had done of Isabella when he had stayed in Mantua a few years before. Flipping through the second notebook in his pile he saw the red chalk sketch he had done of Cesare Borgia just the year before. *He looks almost as angry on paper as he did in person*, Leonardo thought. *And looking at three versions of him at once certainly isn't helping.*

But that was done too recently. I don't think my sketches of Isabella will be in this notebook. Setting the notebook aside he searched quickly through the next several notebooks, resisting the urge to stop frequently and study the machines he had drawn, the flowers he had sketched, or the animals he had placed on page after page. They were all painful reminders of the encyclopedic work he was planning to publish someday – the books on astronomy and painting and geology that awaited his attention along with too many other topics.

"Not now," he muttered to no one in particular, "I really do have too much to think about at this time."

Finally, more than a dozen notebooks of various sizes were stacked precariously on the edge of his table and he held the one he had been searching for. Flipping through it he found several sketches he had made of Isabella. *These are not quite as detailed as the one I left with her when I departed Mantua for Venice, but they will serve my purpose.*

"Salai, please come here, I have a task for you," Leonardo shouted.

Moments later Salai was standing in front of the Master wondering what he had done wrong this time.

"Salai, it's time for you to get some more practice painting." Before Salai could react, Leonardo was continuing, "You have had many lessons with me over the last few years. I will help you get started and can help you if you get stuck, but I have confidence that you can do this."

Salai was stunned, still not understanding what "this" Leonardo was referring to, but quickly surmising that it must have something to do with painting. Salai wondered what the Master had in mind, but was afraid to say anything. Silently he followed Leonardo to the corner of the studio where they kept most of their painting supplies.

Leonardo picked up a small piece of wood from the corner and handed it to Salai. "This should work perfectly."

Salai still wasn't sure what the project was, but he was beginning to get excited. Master Leonardo had in fact given him quite a few lessons in painting, and had even allowed him to do small portions of some of his bigger projects, but he had never been allowed to do an entire painting even primarily by himself.

Leonardo positioned the wood panel on the nearest easel and turned back to Salai. "Do you remember Madam Isabella from our stay in Mantua?"

Salai wondered if anyone who had ever met Madam Isabella could ever have forgotten her, but he politely nodded and said, "Yes, Master, I remember the Marchioness quite well."

Leonardo laughed, "Yes, I suppose you would remember our hostess. And do you remember these?" Turning Leonardo produced two of the preliminary sketches he had drawn of her.

Salai nodded, "Of course, Master. You spent many hours working on the sketches of the Marchioness."

Leonardo smiled. "And you will get to spend many hours painting her portrait."

Salai almost knocked the wood panel from the easel next to him. "Me? Why?" he managed to stammer.

"Because you are ready. And because I am tired of getting messages from her servants. So we are going to give her a portrait – and you are going to paint most of it. You may have Tommaso help you with the preparatory work on the panel as long as you promise to get the gesso on the wood and not on my floor or each other."

Salai brightened, nodded his promise, and went hurrying off to find Tommaso. While he was gone, Leonardo repositioned the wood panel on the easel, holding the largest of his sketches of Isabella next to it. *Yes, this will be the perfect size for her highness' portrait. After Salai and Tommaso prepare the wood, I will transfer the sketch onto the wood and then Salai should be able to take it from there.* Leonardo closed his notebook and went off across the studio, whistling as he went.

Salai and Tommaso managed to apply the white glue gesso to the wood panel without making too big of a mess in the studio. After the requisite drying time Leonardo traced his original sketch onto the whitened background, making slight modifications as he went. He had not

managed to paint Isabella's portrait during the time he and Luca Pacioli had fled to Mantua through no fault of his own. He had done the preliminary sketches, but then she and he had both been called away to other responsibilities. Recently she had started pestering him about the desired portrait and he did not appreciate her demanding manner. *She is certainly a woman accustomed to having her way,* he thought, *so this little compromise should please us both – she will have her portrait and I will still have my honor.*

Leonardo arranged the painting supplies for Salai. He was becoming amused at Salai's excitement over the assignment, and was even more thankful he had come up with this solution. Salai could certainly do more than an adequate job. And he could always touch up the painting himself if needed – one of the benefits of using oils, after all.

<p style="text-align:center">***</p>

Salai stood back from the wood panel. He hadn't shown Leonardo his progress on the portrait for a few days and now wondered what the Master would think of his finished portrait. Salai himself was more than thrilled with the end result. He had placed the small crown on her head as a joke and had fully expected Leonardo to make him paint over it. But when Leonardo had seen it, he had merely laughed, so the crown had remained.

Salai put the paintbrush down, looking over Madame Isabella's portrait once again. He had wondered if he was using too much green, between her dress and the flower he had added to her hand. But now, looking at the completed project, he liked it. He might not be the next Leonardo, but he wasn't too shabby a painter after all.

Chapter Seventeen
Mona Lisa - Florence
June 1504

Leonardo put down his charcoal, allowing himself a few additional minutes to watch the young woman sitting in front of him. He had indeed painted several portraits in the past, most of them younger and more beautiful women than Lisa. But none had struck him in quite this way. As he watched her, he pondered what made Lisa so different. But, at least for now, it was unclear to him.

Carefully going back to his sketch, he strove to capture her personality. He had planned to hire entertainment for her sittings, as he had often done for others who had had to endure the long and tedious sittings that were required for such a work. There was nothing like having musicians to calm an agitated sitter as he composed his masterpieces – first in sketch form and then in the various levels of painting. Leonardo laughed to himself as he thought back to his original work on Isabella's portrait in Mantua. No musicians had been needed there either. Of course, that had been for a completely different reason – Isabella had wanted to engage him in conversation during each sitting.

But Lisa seldom spoke in their weekly sessions. She generally sat still, in a quiet regal way that said more in her silence than Isabella had ever said in her lengthy conversations.

Leonardo sketched, Lisa sat calmly, and time passed quickly. He remained careful to keep their

sessions short as she had requested. She still spoke only occasionally to him, but whenever she actually started a conversation, Leonardo found her to be an interesting woman and he hoped that he would do an adequate job on her portrait to express those attributes. He hoped she and her husband would find the finished painting to their liking.

As Leonardo's left hand continued to work, he was careful to capture the inward beauty of the woman that sat before him. He continued to consider the difference between the two women – Isabella was one of the most powerful and well-known women on the peninsula – possibly in the world, and certainly considered herself to be one of the most powerful. And she entertained some of the most powerful men in the world from their palace in Mantua, or as they travelled to various cities throughout the region. If Isabella wanted something, she generally got it. Leonardo almost laughed out loud at that thought. No, there was one thing she would never have, as much as she desired it, and as much as she whined to him – a portrait painted by his hand! Though now, thanks to the work of his young apprentice, Salai, she would receive a portrait from the workshop of Leonardo, a portrait that might finally put an end to her constant badgering.

It's not that their conversations hadn't been enjoyable, Isabella was a brilliant woman who could converse, and often did, he thought, on countless topics. But, looking back, her assurance and self-confidence now came across to him as demanding, and he was no longer at a place in his life where he had to do a painting for anyone.

Putting the final touches on his charcoal sketch, Leonardo looked back at the young woman who sat in front of him now. She did have one thing in common with

Isabella – neither of them were stunningly beautiful like the other women who had sat for him at other times.

But Lisa was different from Isabella in almost every other way. Her husband was a mere merchant, not the marquis of a powerful city. She was not well travelled, and did not carry herself in the "I can do anything" manner that Isabella had mastered. And she dressed so simply, Leonardo thought approvingly, even below her status of a merchant's wife. She wore no jewels or other fancy fashion statements, even though they could undoubtedly afford them.

Leonardo put down his charcoal and motioned to Lisa that she could relax. She moved but a little and turned her face towards him. "How goes the work Master Leonardo? Will you ever be able to make a suitable painting from such a homely model as myself."

Leonardo shook his head at her last comment. "Madam Lisa, you carry beauty within yourself that would make many women burst with jealousy. Come and see the preliminary sketch. I believe we are ready to begin the actual painting at your next sitting."

Lisa came across the room to Leonardo's easel, taking in the drawing that the Master had created. "It is remarkable, Master Leonardo. I am quite amazed."

Leonardo smile modestly. "Shall we begin the painting process next week? I will need some time to gather the necessary paints. I have some ideas for the background that should work rather well. I will not need you when I am working on those portions, so our weekly sittings shall still be quite satisfactory."

Lisa smiled approvingly and then said a quick goodbye. "I must hurry home Master Leonardo; it will soon be time to nurse the baby. Thank you again for your magnificent work. I am looking forward to seeing the painting come to life."

With work on the Battle painting growing Leonardo soon had to cut their sittings down to less than once a week. Lisa had seemed disappointed at first, but she took the change well. Leonardo found himself wondering if there was much of anything that really bothered her, but from what he had seen, it didn't appear so.

He found himself looking forward to the occasional breaks from the horrors of battle when he had the time to focus on this portrait instead. It gave him time to clear his head and remember what he enjoyed about portrait paintings – the ability, no the responsibility, to show an actual person in a way that both honored and resembled them.

Chapter Eighteen
Battle Painting and Mona Lisa - Florence
June 1504

Leonardo had turned his focus back to his battle painting. He had heard a rumor that there were still a few veterans of the battle of Anghiari living in the area – men that had witnessed the fighting first hand when they were quite young. He would find those men and talk to them about the smell and the sounds that they remembered. Even with his own experiences with war he would be able to better portray the horrors of this particular conflict after interviewing them, of that he was certain.

Leonardo closed his notebook. He had had enough thoughts of fighting for one day - it was time to move to a more pleasant project. He could return to the task of painting Madam Lisa. She had agreed to continue visiting his workshop as long as necessary, and Leonardo suspected she was enjoying the regular breaks their sessions afforded her. He had thoroughly enjoyed the time he had spent sketching Madam Lisa. The conversations with her were more of a domestic type that the ones he had had with Isabella d'Este. Isabella had certainly been a woman of the world, with influences far and wide. But Lisa's world was smaller. She had never been outside the community of Florence. Many of her days were occupied with the care of her family and her home. She had servants, to be sure, including the young lady that accompanied her every time she came to the studio for one of their sessions. But her servants seemed to be more

an extension of her family, whereas the countless servants in and out of the d'Este palace in Mantua were primarily employees, pure and simple.

In some ways Leonardo wondered if Lisa reminded him of his own mother, which was silly he thought, since he was the older of the two. But the way she carried herself, the way she prioritized her family, it all reminded him of his mother – at least his memories of her when she had come to live with him in Milan shortly before her death.

Leonardo found himself becoming melancholy at the memories. He had few memories of Caterina from his younger years, having only seen her a few times in the first five years of his life, since he had been living most of that time in the home of his paternal grandparents. But in the back of his mind he had always kept a picture of her – the young mother he had barely known. Looking back at the Madonnas he had painted as a young artist, he could see the influence of that mental picture.

Caterina had gone on to marry someone besides his father, and to have many other children in her new family. But at the end of her years, when she knew she was fading, she had made the difficult journey to Milan and sought him out. He had enjoyed their final days together, had enjoyed getting to know her more as an adult. And only now did he realize that his latter Madonnas had also been influenced by her – that they portrayed Mary as a much older woman, one with the great maturity he had seen in his mother's final days.

Looking at his sketches of Lisa he could see that maturity. She was neither as young as the mother he had first remembered, not near as old as the one that he could now recall from Milan. But somehow, she still reminded him of her. Maybe it was the ease with which she sat still for him, or the gentleness with which she treated her servant. She showed Leonardo much respect as well,

never talking down to him or treating him as if he was a mere worker. She always showed up on time for their sessions and he made a special effort to finish within the time frame she had requested.

She had a calm about her that he had seldom seen in the other young women who had posed for him to do for their portraits. Maybe it was her age, or maybe her role as a mother. She continued to claim that their painting sessions were a nice little break from the everyday responsibilities of running a household, training her children, and nursing her baby. He was finally ready to believe her.

Now that the sketches were done, he planned to do his absolute best on the actual painting. He wanted all who would see it after he completed it to experience at least a taste of this remarkable woman that had come and sat patiently for him week after week, and never complained.

Leonardo looked away from his easel at the young servant that sat off to one side each time she came. She spoke even less than Lisa, and then only when he or her mistress addressed her. Most visits she occupied herself with needlework that she brought along. But occasionally she would just watch him draw or paint, as if the entire process fascinated her.

Leonardo couldn't help but wonder if she had the soul of an artist. Her hands might not ever touch a charcoal pencil or a paintbrush, but the way her fingers worked their way quickly and yet delicately across the needlework on her lap told him that she had found another way to express her artistic talents. *Someday,* he thought sadly, *maybe someday, women will also be able to express themselves on an easel and not just on cloth. But that time is not now.*

Turning his attention to Lisa, who sat comfortably on the chair in front of her, he had momentary doubts about her true happiness as a wife and mother. But looking

back at his work and then again at her, all his doubts were gone. This woman had happily chosen her roles and it showed on her face every time he saw her.

Later that day, after their session, Leonardo set up both of his smaller easels like he had for the *Madonna of the Yarnwinder* paintings he had painted several years previously. This time he might work primarily on one and give Salai an opportunity to help him with the second painting.

Going to the corner where they kept the wood panels that had already been selected for portraits, Leonardo chose two poplar panels, both almost exactly the same dimensions, and both a fair amount larger than the one he had chosen earlier for Isabella's portrait. He smiled as he looked at his choices. He could try to convince himself that he was not slighting Isabella by doing Lisa's portrait in a larger size, but he didn't bother. It would be another inside joke that she would never know of, but would make him smile every time he thought of it.

Not for the first time Leonardo was thankful that Lisa had insisted on wearing her simple dresses and staying away from elaborate jewelry. He was going to have so much fun with the backgrounds on these paintings. For just a moment Leonardo wondered what it would be like to do a painting of just a landscape. But he had to laugh at the notion. No, there was not likely to ever be a market for such a painting.

He remembered writing his ideas for painting a landscape in one of his notebooks recently. *At long distances the dark colors of the shadows of mountains become a beautiful blue, before the rocks take on a more reddish hue, and turn more to a violet color. Of course, they reveal their colors better the more they are illuminated.*

Carefully Leonardo sketched the figure of Lisa onto both panels – the smile, the hands, the simple outline of her dress. When he was done with that he grabbed his nearest notebook and sketched several ideas for the backgrounds. That was one of the reasons he liked to do two copies of a painting at the same time when he could afford the extra paints – it gave him the ability to try different things – to experiment. He was looking forward to trying different things with the landscape in particular, as he had done when he had painted the two different versions of the *Madonna of the Yarnwinder*. On one of these portraits he had in mind to do something that would have an otherworldliness feel to it.

Chapter Nineteen
David - Florence
June 1504

Leonardo was only a bit surprised when he was invited to be on a select committee of thirty Florentine artists tasked with choosing a location for Michelangelo's *David*. The statue was clearly too heavy to be installed on the top of the cathedral as some had wanted. Leonardo and Giulano da Sangallo, a fellow sculptor, quickly pushed for it to be placed on the Piazza della Signoria, where the roof would protect the marble somewhat from the weather.

But Sangallo and Leonardo lost the fight. They watched skeptically as the oversized sculpture was slowly moved into position outside the entrance to the Palazzo della Signoria, the Florentine City Hall, instead. The statue was not scheduled to be unveiled to the city for another three months, and Leonardo wondered what type of shape it would be in by then.

As Leonardo passed the covered statue each time he came to work on his battle painting, he wondered what the citizens of Florence would think of the sculpture after all the waiting. Frankly, he didn't care one way or another. He had turned down the commission long before they had given it to Michelangelo, and he was perfectly content with his current projects. Sculpting was a dirty job and he much preferred painting.

Chapter Twenty
Father's Death - Florence
July 1504

One hot summer morning Leonardo's work was interrupted by news that his father, Ser Piero, had passed away. While processing the message, he looked casually at his notes from a partial letter he had composed at some point the previous month, but had never sent his father: "I received your recent letter. I was saddened to hear of your failing health. I wish you and your family the best."

Now the letter would never be sent and Leonardo would choose not to attend the reading of his father's will, fairly confident that there could be no surprises in it. As he had said in his unsent letter and as his father had always made clear, Leonardo may have been the eldest son, but he was not a member of the family.

Across the studio word spread among the apprentices of Ser Piero's passing. Most had never met the man and thought little of it. Hearing the news, Salai immediately came up with a plan. He was going to sneak out of the studio and discover for himself what was up with the will. Surely Ser Piero would not exclude his eldest from everything. He had invited Tommaso to join him on his mission, but Tommaso wasn't willing to risk the Master's anger if he caught them.

Salai found his way to the part of town where Ser Piero had worked as a notary and casually hung around the street near the office of his master's deceased father. He waited impatiently until a throng of people exited the

building. Approaching one the younger servants, Salai asked, "Was the will read? Were there any surprises in?"

The young man looked at Salai with suspicion, considering whether or not to answer the question. "No surprises. Ser Piero has taken care of his eleven children quite well. The nine sons received double portions and the two daughters received single portions. None of them will lack."

Salai made his way slowly and sadly back to the studio. The Master had been wise to stay away. Ser Piero had only divided his assets among his eleven legitimate children; Leonardo, his eldest, had indeed been left out. Salai wondered if Leonardo would need to be told, but then thought better of it. *No, if there had been better news, someone would certainly have rushed to tell him about it. Since he has no news, he will know exactly what that means.*

Chapter Twenty-One
Battle Painting - Florence
September 1504

Tommaso rushed excitedly into the room where Leonardo worked intently on several sketches. He stood breathlessly by Leonardo's side waiting for his master to take a break from his work. Leonardo finally paused and looked up at him. "Well?" he asked, almost imperceptibly.

Tommaso gulped. He had thought that the Master would want the news right away, but now he wondered if interrupting him had been such a good idea. *Oh well,* he thought, *I've done it now.* "Did you hear the news?" He exclaimed. Without waiting for Leonardo to answer, Tommaso continued, "Master Soderini has given Michelangelo the commission for the wall across from your fresco, I mean, mural. It is being talked about as a competition between two master painters." With that, Tommaso took a breath. He was almost afraid to see Leonardo's reaction.

Much to Tommaso's surprise, Leonardo shrugged his shoulders and turned back to his sketch. Tommaso began to think that Leonardo was not going to respond, but just as he prepared to leave the room, Leonardo looked up again. "Who the council commissions is not my concern. What Michelangelo does or does not do is not my concern. My concern is our task, the one that you have just interrupted. If you will kindly leave me alone, I will continue the sketching for my own commission – the only one to which I should be concerned."

Tommaso wasn't sure whether the Master was angry at this ill-timed interruption, but as he prepared to exit the room, he realized that the Master was whistling. *I guess he really doesn't care about Michelangelo,* Tommaso thought as he departed. *I guess I was worried for nothing.* With that thought comforting him, Tommaso went in search of Salai.

As Tommaso departed, Leonardo finally looked up from his work, only slightly more unhappy by the interruption than he had let on. Thinking of what he knew about the young man, he was surprised at Soderini's choice. *There are so many other world class artists in this city, why would they choose him?* he wondered more in confusion than in frustration. *Michelangelo is not a true artist, he is a sculptor. Sculptors work more by force to wear away the stone they work with. It is a mechanical exercise that is accompanied by an equal amount of sweat and dust. There is a reason that I paint and he sculpts. But regardless, I am not going to allow Soderini and the other city fathers to take away my pleasure in what I do. They may consider it a competition all they want. I was commissioned to do a battle painting, not to compete with someone, and that is what I will do.* With that promise to himself, Leonardo went back to his work.

Chapter Twenty-Two
Arno River

October 1504

Machiavelli entered the studio cautiously. He had interrupted Leonardo's work enough times to know what the initial response to his visit would be. And unfortunately this time he knew the follow up response wasn't likely to be good either.

He knew Leonardo had been trying to balance work on his battle painting, work on his portrait of Lisa, and the continued work on the Arno River project. Machiavelli felt like he was balancing them well, but it seemed that the City Fathers did nothing but complain. When Leonardo was working on the battle painting, they wanted to know why work wasn't progressing faster on the diversion project. But if he went out in the field to help oversee the workers there, they complained that the painting wasn't coming along fast enough. And Machiavelli seemed to get the brunt of all the complaints, when they were afraid to reach out to Leonardo directly.

Well, this news isn't getting better with age, Machiavelli thought glumly. "I'm sorry to interrupt your work again, Leonardo," he started carefully.

"Then don't." Leonardo responded without even looking up.

"I bring news about the Arno River Project from Master Soderini."

"And clearly, from the look on your face, and the caution with which you speak, this is news I won't be particularly thrilled with, isn't it?"

Again, Machiavelli hesitated before answering. "The City Fathers have hired Master Colombino as 'master of water,' to oversee the project onsite."

Leonardo stopped what he was doing and peered at his friend. "What else?"

Machiavelli shook his head. "That was it. I was just instructed to let you know of his assignment. They assure me that you are still in charge and are welcome to go out to the River at any time you wish. But…"

"But what?" Leonardo interrupted.

"But you are very busy with your painting projects and they felt like it might be best to take away some of the responsibility you were burdened with."

"I see. So I am no longer in charge, but I am in charge. So if this Master Colombino makes a mess of the project, they will blame me. But if he succeeds in finishing what I have started, they will credit him. Do I have that about right, Master Machiavelli?"

"Um, well, I suppose."

Leonardo shook his head. "Please tell the city fathers that they may consider this my official resignation from the Arno River project. I have provided them with complete plans for how to dig the canals to divert the river. I have offered to stay onsite and ensure that the workers follow the plan to its completion. But they have insisted I stay in town and paint. So here I am. I want neither blame nor credit for the project. I merely want to be disassociated with it. Now, if there is nothing else, I will return to my studies, so that I may then return to my painting. I would hate for the City Fathers to want to fire me for two different failures too close together."

Machiavelli stood silent for a few moments, finally deciding it would be best to say nothing more. He turned and let himself out. Maybe the next time he came he would have some sort of better news.

Chapter Twenty-Three
Raphael - Florence
October 1504

Raphael had shown up at the studio unexpectedly, during a time when Leonardo was hard at work on the battle cartoon. It was good to see the young artist again.

Leonardo smiled as he noticed Raphael standing quietly in the studio. "I see you are still carrying a small notebook with you, Raphael."

"Of course, I was given that suggestion by more than one artist I respect, as I recall."

Leonardo accepted the indirect compliment and Raphael continued, "You had invited me to come visit you whenever I had a chance. My other work has taken a break, and I wanted to come see what was going on here in Florence. I see you have been hard at work since returning."

Raphael walked around looking at the various works in progress that lined the busy studio. "While at work in Siena I was hearing about your work on the great battle painting. But I see you have been hard at work on a portrait and a Madonna at the same time."

Leonardo nodded, "I enjoy the variety. Working on the battle painting is something I have to do a little at a time. I find the topic too depressing to concentrate on just it for long. For most of the City Fathers it is merely their history, or maybe even a vague concept. But, for me, thanks to my experiences in the employ of Cesare Borgia, it is much too real."

Raphael could imagine his friend feeling that way, though he too, fortunately, only knew war as an idea. "Do you mind?" Raphael asked, taking out his notebook in hopes of making some copies of the magnificent works in front of him.

Leonardo shook his head. "No, of course not. Copy away. Will you be in Florence long? If you need a place to stay, I'm sure we have some extra room here in the studio for another person."

"Thank you. That is very kind. I may take you up on that. I don't know yet how long I will be staying. I'm hoping to get some commissions while I'm here. And of course, I was looking forward to further discussions with you about your current projects. Do you not find it difficult to address both scientific and artistic pursuits at once?"

Leonardo shook his head. "No, the ability to go between the two helps me with both areas. My scientific work aids my work as an artist. But my artistic abilities also come in handy as a scientist. It is hard for me to imagine one without the other."

Raphael pondered his older friend's words. He himself was focused almost exclusively on artistic pursuits. But Leonardo certainly gave him something to think about.

Leonardo continued, sensing that Raphael was interested in hearing more of his ramblings. "When I paint, I generally have at least a fairly good idea where the journey will take me. I am generally trying to bring some sense of reality to what the finished product becomes."

Raphael nodded again, considering his own artwork. Leonardo continued, "But in my scientific work my mind can explore an unchartered course. It is more like following a meandering river that leads off in an unknown direction. With science, whether I am studying anatomy or biology, geology or zoology, I am given the pleasure of

seeing new things, of discovering new connections. For me, I could never have one without the other."

Chapter Twenty-Four
Michelangelo's Battle Painting - Florence
October 1504

Michelangelo had taken the commission to paint a second battle painting, though he wasn't overly thrilled with the idea. He didn't consider himself a painter – that was something for old men like Leonardo. He wanted to continue to work with his hands, to bring marble to life, not paint. Leonardo might enjoy mocking sculptors but Michelangelo knew it was really because Leonardo had failed as a sculptor, not because there was anything wrong with the art of sculpting. He had heard plenty of rumors about Leonardo's reactions when he had been given the commission to do the *David* sculpture and when the sculpture had been unveiled to such high praise.

Others had tried to tell him that the old man didn't care, that he wasn't jealous, but Michelangelo knew better. He had seen the look in Leonardo's eyes every time he passed the sculpture that now sat right outside the building that Leonardo was painting in and the jealousy, it was there.

In fact, that was the reason Michelangelo had finally agreed to paint the battle scene on the wall opposite Leonardo. He would taunt him daily with his superior work. He would win the contest that was being spoken of as the "Battle between the Masters." But Michelangelo knew better. Leonardo was an old man, beyond his prime. He was also painfully slow, and even though he had started

before Michelangelo had no doubt he could finish his fresco long before Leonardo ever did.

It had only taken Michelangelo a little while to decide on what battle he would portray on his wall. He was going back almost 150 years to find his inspiration – to the Battle of Cascina. It had been a Florentine victory against the Pisans, which was a good choice since the Pisans had been harassing the Florentines yet again. It would be good for the Florentines to be reminded of a previous victory over their neighbors.

Michelangelo knew Leonardo would try to show the terror of war, he had harped on that subject many a time. But Michelangelo wanted a better way to show off his anatomical expertise. He would show the soldiers in the scene that preceded the fighting – as they were all caught off guard in the process of bathing. That would allow him to focus on their muscles in a unique way. And it would be a much more fun fresco than the overly serious one Leonardo was working on!

Chapter Twenty-Five
Leonardo's Battle Painting - Florence
October 1504

Leonardo had finally finished his rough outline for the entire wall, but then had decided to focus first on the center section for painting and work his way out both directions from there.

Salai and Tommaso helped several of the apprentices carefully glue together the small pieces of paper needed to make one large enough for this first cartoon. Tommaso tried to avoid touching the smelly glue any more than he had to. After a few false starts and more than a few harsh words thrown at each other, the group of young men finally declared the paper large enough and the smaller pieces secure enough.

Tommaso was sent to the back of the workshop to tell the master that the paper for the cartoon was ready. He found the master hunched over his science table again, this time carefully examining his latest experiment on water flow.

Tommaso came up next to him, hoping he would look up soon. After standing quietly for several minutes, Tommaso finally realized his hope of being spoken to was in vain. His legs would likely give out long before the Master's would. But, oh, how he hated to be the one to interrupt the master at work.

Finally, he blurted out, "Master, the paper for the cartoon is ready for you. It is on the floor on the other side

of the studio as you had requested. Salai asks what you would like them to do now"

As happened at a seemingly increasing rate, Leonardo ignored the question, continuing his work. Just as Tommaso was about to brave a second attempt, the Master looked up.

"Thank you, they may leave it where it is for now. I am quite certain the glue has not had time yet to dry adequately for me to use it. But please tell the others to stay away from it now. I do not want to be sketching around dirty footprints again."

Tommaso nodded his head, wondering if it was safe to leave. The master seemed to have turned his attention completely back to his present work.

As Tommaso hesitated Leonardo looked up again, shooing the young man away with his right hand. "Be off with you. I will attend to the paper at some point later this afternoon or tomorrow when I am quite ready."

Tommaso didn't need to hear more, he was off across the studio and out the front door as quickly as he could move.

<p style="text-align:center">***</p>

For the next several days Salai and Tommaso found work to occupy themselves where they could keep an eye on the paper and watch for the Master. He hadn't asked them to stand guard, but they liked the idea of keeping an eye on it for him.

"Do you think he'll actually come work on the cartoon today?" Tommaso asked as he leaned on the broom he had been sweeping with. "I don't think we have much more work to do in this part of the studio. I think it's as clean as it's ever been, and frankly I'm tired of sweeping a clean floor."

Salai leaned back against the wall, watching his friend. "You don't have to actually work, Tommaso. Just

look like you're working, so that the Master doesn't think we've just been standing around."

"But isn't that what we're doing now?"

"Of course it is, but the secret is to not make it obvious."

Tommaso shook his head. He didn't like the idea of misleading Master Leonardo that way. But he truly had run out of things to do.

"I do think the Master will come today. He was finishing up some crazy project to do with his ideas for flight when he left the studio yesterday. I think he's ready to get back to this project. Start sweeping, Tommaso, I think he's finally heading our direction."

Tommaso sighed and started sweeping, trying hard to find something on the floor that was actually out of place.

Leonardo strode into the room and walked across it, seeming to ignore the two young men. He walked over to the paper, walking around and confirming for himself that the various edges of paper had been sealed well. As he finished his examination, he called to the two young men. "Don't just stand there pretending to work, gentlemen. Go find a few of the apprentices and have them help you carefully secure the paper to the wall. I am going to collect the chalks and the sketches that I want to use. It would be nice if the paper was attached to the wall when I returned."

Tommaso and Salai wasted no time running off to find some of the others. By the time Leonardo returned to the wall the group of young men was just finishing. Leonardo looked over the paper again, satisfied with the way it looked. The young men backed away to allow the Master room to work. The others left to return to the projects they had been working on, but Salai and Tommaso merely moved back to the far side where they

had been before. They liked to watch the Master work and they wanted to be close by if he had need of anything.

As they observed, the entire cartoon slowly came to life. The Master seemed to capture the intensity of the fighting even more so in this larger than life scale than he had with his original sketches.

Tommaso had never noticed the flag in the smaller sketches he had peaked at. "Are the men fighting over the flag there in the middle?" he whispered to Salai.

"Yes, heard the Master refer to this portion of the painting as 'the battle for the standard,' it's what he's going to focus on here in the middle of his wall."

"I can see the savage power of the horses and the rage of the soldiers. It makes me nervous just seeing it all on the paper."

"It doesn't look much like the calm figure of David that Michelangelo sculpted, does it?"

Tommaso agreed, studying the cartoon more closely. "I never thought of David as a soldier. But, no, he certainly doesn't look anything like these men. Here I imagine a fight going on. Master Michelangelo's sculpture doesn't make me feel that."

The two men watched in silence for a time. It seemed that the Master would cover the entire paper with chalk before he took a break.

"Do you think we'll be taking it to the Hall today?" Tommaso whispered as Leonardo seemed to come to a conclusion.

"I don't think so," Salai whispered back, "Leonardo doesn't seem to want to spend too much time each week on this painting. I would imagine this will be it for now."

Tommaso nodded, that had certainly been his hope, but with their master, one never knew.

Salai continued, "But we better not disappear until he dismisses us, or sure enough this will be the day he'll want our help all day."

Tommaso and Salai quietly watched Leonardo from across the room. After studying the sketch for a while longer, Tommaso whispered, "The cartoon makes me afraid. I can't imagine how terrifying the actual painting will be."

Salai nodded. "We have been far too close to the fighting he portrays."

Tommaso cringed. "This wall will give me nightmares of our time with Master Borgia."

Salai agreed again. "It will be a truly magnificent painting if the Master completes it."

Tommaso's eyes opened wide and he looked around anxiously before speaking again. "Salai, you shouldn't say such a thing."

Salai grunted. "And why not? You may not have been with the Master as long as I have, but you certainly have been around him long enough to know how bad he is at finishing things! When we were in Milan I didn't think he would ever finish the *Last Supper*. I don't know who was getting madder at him there at the end, the Duke of Milan, or the head of the monastery where Master Leonardo was working. I found the whole matter to be quite entertaining."

Tommaso looked around fearfully as if he was afraid someone would overhear them. "But surely Leonardo will not risk angering the city fathers by not finishing this painting. Would he?"

"Who knows? With our master one can never be too sure. If he wasn't afraid of the Pope or his son, Cesare Borgia, I can't imagine him being afraid of anyone. Surely you've heard him arguing over the schedule the city fathers expected him to keep? He's not going to be rushed on anyone's account."

118

Tommaso had to admit his friend was right. There didn't seem to be anything that would make Leonardo move faster than Leonardo wanted to go.

"I suppose you're right," Tommaso answered reluctantly. "I just hope he does enough work to keep getting paid. I don't particularly like meals at the studio when commissions are slow in getting paid."

"Yes, but you can't really blame those who hire him if the work is slow in getting done."

Tommaso looked around again and then whispered, "Do you think that's why the Pope didn't hire Master Leonardo? I heard multiple popes have hired artists away from Florence, but not one has invited Leonardo to come paint for them, even though he is the best painter in all of Europe."

"No, in all the world! But yes, I have heard rumors to that effect. And I do believe them to be true. Even from his early years as a painter Leonardo was known for not finishing paintings in a timely fashion, and too often not finishing them at all."

"Well," remarked Tommaso, "as long as we have enough food on the table, I don't care."

It was several more days before Leonardo was ready to have the cartoon carefully moved to the Great Hall. He had gone back to his flight experiments and his work on Lisa's portrait almost as soon as completing the sketch on the cartoon. By the time he was ready to return to the carton itself, he knew the City Fathers were starting to get anxious again. He wasn't concerned; they could sweat a little while and anticipate his next step.

Back in the Great Hall, Salai directed the others as they carefully attached the paper to yet another wall. Now they would certainly have to attach it well, since the paper

could not slip while Leonardo was transferring the picture to the wall.

Salai wondered if the Master would actually do the transfer today or make the City Fathers wait again. He could hear a storm brewing outside and hoped they would not being heading back outside anytime soon. He was relieved that the Master approached the wall almost as soon as he stepped away from it.

Quickly examining the way the paper was attached to the wall, Leonardo nodded his approval and asked for his scaffolding to be moved into place. He would start at the top of the drawing, just as he would later do when he was painting.

As Leonardo carefully punched the holes in the cartoon paper and applied his chalk through each hole, he listened to the rain and wind. *The weather sounds as unhappy as I am,* he thought miserably, wondering again why he had allowed himself to be talked into this commission. *When am I going to learn to say no?* he scowled at himself. Just then the bell resounded and at that moment the window above him broke loose. The wind and rain rushed through the new opening, and the cartoon started to tear away from the wall. Leonardo climbed higher onto his scaffolding, slammed the window closed and called out to Salia, "Quick, bring me something to brace this window with, before the entire cartoon is soaked."

The room was soon a flurry of activity as different people worked to securely close the window and then to make sure the other windows were all well secured. Salai and Tommaso looked in dismay at the tears in the paper. It had originally looked like Leonardo would work until the entire picture was transferred, but now there would most certainly be a delay.

Chapter Twenty-Six
Piombino

November 1504

Machiavelli had just returned from the coast. Things were not going well at Piombino and he was going to need Leonardo's assistance to make things right there. *Why does it seem that I'm always the one who gets sent to talk to Leonardo?* Machiavelli thought miserably.

He entered Leonardo's studio expecting to find him working on yet another science experiment. *And anyone wonders why he is so far behind on the other tasks he has agreed to?* Machiavelli asked himself as he let himself in.

Instead, Machiavelli was surprised to find Leonardo working on the portraits of Madam Lisa. *But I guess he has to work on that commission sometimes as well,* he thought. Before interrupting Leonardo, Machiavelli peered at the portraits that had come so far since he had last visited the studio.

I'm not much of an artist, Machiavelli thought, *but I can still appreciate the work of a master artist. Everything about this portrait seems unusual, from the elevated position of the sitter to the partial columns that frame the picture. I wonder how Leonardo makes these decisions.*

As was so often the case, Leonardo barely acknowledged his presence, continuing to work on the portraits on both easels. Before Machiavelli could bring up the reason for his latest visit, Leonardo had turned to him and scowled. "I really have no desire to see you these

days, Machiavelli. Your work with the City Fathers seems to bring no end of assignments that I will not like."

Machiavelli shrugged indifferently before responding. "But what about the battle painting? You are enjoying the painting, right?"

"Of course I enjoy parts of it – primarily the creative process. But I don't enjoy the constant feeling of someone looking over my shoulder, the deadlines that men who have never touched a paintbrush try to set, and the general unreasonableness of the requests, no, requirements, of the City Fathers. And you are to blame for at least a portion of this. So, again, why do I want to listen to yet another idea that you want to bring to me?"

Machiavelli hesitated, and then asked, "So, are you ready to do a little traveling again, Leonardo? We need you to travel back out to Piombino. Jacopo d'Appinao is in need of your assistance."

Leonardo turned, brush in hand. "And what exactly am I to assist Lord Appiano with and why is it more important than the tasks I am currently working on?"

"His fortress is in need of repairs and you are the perfect person to do it."

"Because I have nothing better to do with my time, is that what you're saying?"

Machiavelli struggled to come up with a satisfactory answer. *Why is it that being with Leonardo seems to bring out the worst of my communication skills?* he pondered. "Nothing of the kind, Leonardo. You know the fortifications of Piombino well, from your time there when you were advising Cesare Borgia. Now that Borgia's father has died, his influence in this area is finally being lessened. But Florence needs to keep Lord Appiano on our side as the political winds change across the peninsula."

Leonardo had finally put his paintbrush down and at least seemed to be considering Machiavelli's words, so

Machiavelli pushed on. "The City Fathers will continue to pay for your studio and living quarters here. Your apprentices may stay on here and work in your absence if you would like, and you may take Salai and Tommaso with you, or leave them here, as you wish."

"How long is this new assignment expected to take?" Leonardo finally asked.

"Well, as always, they would like you to leave as soon as possible. It is thought that even two months of your assistance there would be enough to make a difference, though you may take more time if you see fit."

Leonardo motioned for one of the younger apprentices to come forward from the corner he seemed to be skulking in and to take the paint brush he was holding. "You may clean that well, apparently my painting once again takes a back seat to other responsibilities."

Leonardo turned back to Machiavelli, "You may tell Master Soderini and the others that I expect my contract for the battle painting to be amended to take into account this delay. And I'm not running off to the coast without at least a few days to get my affairs in order here. It will take at least that long to pack some of our belongings and to leave instructions for those I leave behind. Assuming both Salai and Tommaso desire to go with me, I will leave my assistant, Jacopo the German, in charge of my studio in my absence. It will be up to you, Machiavelli, to assure that he receives an adequate share of my monthly allowance to purchase food and supplies for those who will remain behind. I hope that is an acceptable arrangement, or you may go back and tell the City Fathers that I declined their generous offer."

Just as Machiavelli was about to nod his agreement, Leonardo added one more condition. "Oh, and we expect to have horses to ride. Good horses that can handle our weight and the limited supplies we will take with

us. That is not negotiable either, Machiavelli. My days of walking long distances have ended."

As he had agreed, Leonardo, Tommaso and Salai were soon on their way to the coast. As someone who was always looking for an adventure, Salai had agreed to the trip without hesitation. But Tommaso had taken some convincing. He had become quite comfortable in their new home and wasn't sure more adventures were what he desired. But in the end he couldn't bring himself to be left behind, and had joined the small group reluctantly.

Within days of arriving in Piombino Leonardo had fallen back into his role as a military advisor. A quick survey of the fortifications had been followed by significant sketching and then a meeting with Lord Appiano. "You can certainly build on what you have here now. You will need to flatten the hills behind the trenches for a better line of sight. By adding a deep trench here and there, each with low sloping earth banks in front of it, you will add to your defensibility."

Just as quickly Leonardo seemed to be everywhere at once, giving instructions on where to dig, where to move rubble and extra dirt to, and how to link it all together with a covered passage.

Salai and Tommaso generally followed along behind their Master, trying to look important, while also secretly wondering if they should have just stayed back at home with the others. When they got really tired of Leonardo's official duties, they made their way to the coast, walking along the beach, enjoying the sand under feet, while trying to avoid being splashed by the cold water.

Tommaso expressed his wish that they were somewhere else. Anywhere else in fact. He drew closer to

Salai, whispering, though they were the only ones along the shore. "I miss Florence."

As the two young men looked out at the sea, it seemed that both of their thoughts went to all that they had experienced together in the last two years. Almost as if on cue, the clear air was replaced by a fog that seemed almost as gloomy as they felt.

<p style="text-align:center">***</p>

By the middle of December the weather was worsening and they had accomplished all they had come to do. Soon they were packing up to head back to Florence. Salai was disappointed that the trip had not been more exciting, but he could tell Tommaso was relieved.

"Don't you think it was more fun when we came here the first time, Tommaso, when the Master was working for Borgia?"

Tommaso shuddered at the thought. "Nothing was more fun about that time period, Salai, and you know it."

"But all we did this time was watch the Master talk about mounds and ditches, and lines of sight and smoothed banks. This was boring. We could have stayed in Florence and had more fun at the studio."

Tommaso shook his head in frustration. "This was your idea, not mine. I'm just glad we'll be back with the other guys by Christmas time. With all this work the Master has been receiving lately, maybe we'll even get to enjoy Christmas this year."

Salai frowned. "What's to enjoy? We'll probably get drug to some late night mass in one of the fancy churches that are everywhere in the city. Nah, nothing to look forward to there. But I really had been looking forward to more excitement on this trip."

Tommaso clearly didn't share Salai's disappointment and quickly changed the subject. "What do you think the Master will start with when we return home?"

"It's hard to say for sure, but it seems likely that it will have something to do with a painting, wouldn't you think?"

"If he doesn't get distracted right away by his endless science studies, then, yes, it would have to be either the portraits of Madam Lisa that you've been helping him with, or his battle painting. That's the one the City Fathers will be pushing him to work on."

Chapter Twenty-Seven
Both Battle Paintings - Florence
December 1504

Michelangelo had studied the battle at Cascina carefully before laying out his plan for the wall across from Leonardo's. He had read of the summer heat that had hampered the fighting. The need that the soldiers had found to cool off in the nearby river. The surprise when the enemy soldiers had caught them unprepared. That was the moment that he would depict in his fresco. The frightened soldiers hurrying to grab their weapons, to hastily prepare for a battle they were unprepared for. But a battle that he knew they would win against all odds.

He would show the bodies as they twisted and turned, to best show off his understanding of human anatomy. Leonardo was not the only one who had spent countless hours studying how every muscle of the body worked together, struggling to show movement even in a simple work of art. Now, he would show them all that he was also capable of showing that and much more.

In less than two months Michelangelo had announced to the City Fathers that he was prepared to transfer his sketches to the cartoon. Workers were brought in to transform the many smaller pieces of paper into the one large piece he needed. Soon they had pieced together a single paper that measured twenty feet by sixty feet. The paper lay out on the floor of his workroom at the Hospital of the Dyers.

Michelangelo had been enjoyed working in his space here at the hospital. It was not too far from his family's home in the Santa Croce quarter and enabled him to keep an eye on what was going on there while he came and went to work.

Soon his focus would turn to his work on his actual painting at the Great Hall. There would once again show the city which of the many artists here was truly the best!

Chapter Twenty-Eight
Battle Painting - Florence
January 1505

Returning to the Great Hall for the first time after their return, Leonardo was not surprised to find Michelangelo hard at work on his wall, across from Leonardo's work. It appeared that he had just finished transferring his cartoon to the wall and was studying the progress so far. Leonardo smiled as he watched the self-confident young man. *He has no doubt who will win this competition, does he,* Leonardo chuckled to himself, *and it is quite clear he doesn't think it will be a washed up old man.*

Leonardo ignored the young man and walked to his place in front of his own wall. He had been called away in the midst of transferring his cartoon to the wall. In fact, now that they were back he had clear memories of the day the storm had come and the cartoon had been torn.

Studying the remaining portions of the cartoon he was surprised to see that the tears had been repaired. He didn't remember asking his assistants to see to the paper when he was called away to Piombino. But someone had certainly seen to the task.

Moving closer to the wall, Leonardo took his punch and his chalk and went back to the process of transferring his cartoon from the paper to the wall. He started where he had left off two months before, moving carefully but quickly across the remaining section of the wall. Putting

the large piece of chalk away, he pulled out a smaller, sharper piece to draw in a few of the finer lines.

When he had completed his task, Leonardo moved back to the center of the room. He considered both walls briefly and then slipped back out of the Great Hall, without a word to the young painter sculptor standing smugly in the midst of the large room. *Time will certainly tell, time will certainly tell.*

<p style="text-align:center">***</p>

Another week passed before Leonardo was willing to return to the Great Hall. He had kept himself busy with one project after another and Salai wondered if he would ever return.

But one morning, just as they were finishing breakfast, Leonardo called them to join him at the Hall. It was time to get back to work on the "Great Battle" as they had all begun to call it.

Entering the Hall Salai and Tommaso were both surprised to see other artists standing around in groups examining the cartoons on both walls. Some even seemed to be sketching the oversized drawing.

Leonardo seemed to not even notice the extra men in the Hall. He motioned for his scaffolding to be put back into place, and carefully lowered it so that he would be at the right level to work on the middle section of the wall. Silently, he climbed back up, and went back to work on transferring the sketch, working as if he had never been interrupted.

A couple of times he climbed down, adjusted the scaffolding, and went straight back to work. When he reached the lowest section, he motioned for his assistants to move the scaffolding completely out of the way.

Eventually all had been transferred to the wall and Leonardo motioned for the scaffolding to be put back in place. Motioning to Salai and Tommaso, he instructed

them to get up and carefully remove the paper from the wall. Both men worked carefully and as slowly as they could manage, occasionally looking at each with concern. What if they did something wrong, they were both wondering.

By the time they had reached the bottom section, and removed the final pieces of paper from the wall, they both realized they were barely breathing.

Stepping away from the wall they both sighed in relief. They hadn't smeared any of the Masters work. As they studied the wall they became aware of a new noise around them. It took them a few minutes to realize that everyone else in the room seemed to have broken out in applause.

Leonardo gave a slight bow to his audience and walked up next to Salai and Tommaso. "Yes," he spoke quietly, "I have certainly shown the brutality of war."

Chapter Twenty-Nine
Flight - Florence

May 1505

The battle painting had consumed too much of his time, Leonardo thought in frustration. Just because the City Fathers had commissioned him to do the work on it, and were paying him a reasonable salary, he was not obligated to spend every waking minute on their project. He had successfully transferred the picture from his notebook to the cartoon to the wall. Surely that would hold them off for a little while so he could return to some of his other studies.

He had spent many hours in the past studying birds and bats – how their wings worked and how they used the air to accomplish their flight. He was still convinced that man would someday fly, it was just a matter of exactly how that could be accomplished.

His earlier notebooks had been filled with countless sketches of birds in flight and he found himself filling numerous more pages with variations on that theme. He had come close to attempting flight in Milan, but it was another project that had been thwarted by his hasty departure from the city after the French had arrived. He had also seen a failed attempt at flying while he was on the Adriatic Coast with Borgia. Fortunately, the flyer had escaped the rubble relatively unharmed.

Now, he felt like he was coming closer on a design for his own glider. He was certain that they would be able to take it out to the nearby mountain soon and test it out.

Chapter Thirty
Arno River

May 1505

Leonardo had heard that Michelangelo had been called back to Rome by the Pope. For some reason the younger artist's absence made it even easier for Leonardo to keep some of his focus on other tasks. Leonardo was glad the City Fathers were now willing to listen to his newest idea for the Arno River. He knew quite well that they could not blame him for the failure of the first attempt; had they followed his instructions he was still confident that the diversion of the Arno would have been successful. But they had chosen to put Master Colombino in charge onsite and he had completely disregarded Leonardo's plan. One deep canal had been unsuccessfully replaced by two shallower canals. Leonardo could have told them it was a bad idea. Now they knew.

But that was over and he had willingly moved on to many other projects before now revisiting the Arno River. Now his focus was on peaceful work, not the type that involved fighting. He stood once again in front of the City Fathers, but this time it was of his own initiation.

Master Soderini spoke first. "Master Leonardo, how good to see you again. We are happy with the progress thus far on your battle painting. But, Machiavelli has been telling us that you have a new project to propose to us. Please continue."

Leonardo bowed slightly and motioned to the assistants he had brought along to roll out the large map

they had carried in. "Here, as you all well know, is the Arno River, moving in its winding route from Florence towards the sea. As you all know the route our river takes makes travel by sea effectively impossible."

Leonardo moved his left hand a slight ways from the city. "But here, you can see where I have drawn a canal, a canal that will straighten out those sections, allowing us to sail our cargo and our travelers through to the coast."

He continued, "I worked much with canals during my years in the service of Duke Ludovico and know well how useful they can be. In addition to benefiting the city directly, the canal will add to the city's treasury through taxes and tolls. My calculations show that you could easily collect 200,000 ducats per year once the straightening of the Arno had been accomplished."

As Leonardo had expected, the vast sum he was suggesting had certainly gotten their attention. "I am prepared to begin this project as soon as you have given your approval and provided the necessary funds for workers. If any of you have any questions, I would be happy to answer them now."

Leonardo paused and waited to see what their response would be. He was well aware of how they had reacted when they had called off the original Arno plan. They had merely gone back to business as usual with Pisa, increasing their attacks on the neighboring city, threatening them, and basically continuing to waste time and resources. He hoped that they were now ready for a positive solution to their Arno River dilemma. If not, he too had plenty of other projects to keep him busy.

Chapter Thirty-One
Mona Lisa - Florence

June 1505

Leonardo considered the landscape he would paint on the left side of the painting. He carefully sketched a winding road that would go back towards the distant water and mountains he imagined for the top left portion of the paintings.

On the right side he draw a flowing river and a small five-arch bridge, borrowing from some of the arches he had seen in Rome. Even as he drew the bridge that his mind's eye saw, he realized that it resembled one he had seen while traveling with Cesare Borgia. Beyond the bridge the river flowed towards more water and more mountains. The landscape would bear a slight resemblance to the landscape he had done in the background of one of the two earlier *Madonna of the Yarnwinder* paintings, but this one would be much better.

This painting would require a large amount of the expensive blue paint that he like to use for these portions of his portraits, but he was confident that Lisa's husband would be willing to pay for it. He had been instructed to bill the merchant as needed for such extras, and had regularly been reminded not to skimp.

Leonardo was enjoying painting in a style that resembled his original portrait, the one he had completed of Ginevra de' Binci almost three decades earlier. It was a nice change from the Milanese portraits he had done in between. With those, his subjects had worn such

elaborate clothing that his backgrounds had had to be particularly simple.

But the mysterious background he had in mind for Lisa's portrait would go well with the unusual smile Lisa always seemed to wear. When they had begun their sessions together, Leonardo had often wondered if she was really as happy as she had first appeared. But as their time together had increased, he had decided that yes, she was indeed the most content woman who had ever sat for him.

Their sessions had always been pleasant, and she seemed to genuinely relax as she sat almost regally in the chair before him. During most of their sessions, she hadn't been much for conversation, always seeming more at ease in the quietness of that corner of the workshop. Several times he had worried that the noise the apprentices were making in another part of the workshop would distract her, but she seemed much more capable of tuning out their noises than the other young women he had painted in the past. *Maybe, it was her age,* he thought, *or maybe it was the time she spent around her children.*

Chapter Thirty-Two
Painting the Battle Painting - Florence
June 1505

Leonardo had been considering his paint formulas for several weeks now. He knew too well the problems his *Last Supper* had started having before he had even left Milan. He was reluctant to make that mistake again, especially with such a large mural as this one. The City Fathers tried to convince him to use the standard fresco methods, but he was having none of that. If they wanted him to do this work so badly he was going to do it his own way. And while he might be willing to use a different formula than the one he had used on the *Last Supper,* one way or another he was still going to use a mixture of oil glazes and egg tempera on a dry wall, just as he had done in Milan.

Leonardo poured over his translation of Pliny's work again. He had bought it at some point in the distant past and knew that somewhere in it he had seen a formula for painting large murals such as this. Now that he wanted to use it, it seemed to be nowhere to be found.

Once at the back of the book he turned it over and started back again, racking his brain trying to remember the location on the page where he had seen the recipe. Just as he was about to think he had imagined it, he spotted it. The recipe was short, and had been tacked on at the end of a page, almost as if it was an afterthought by the printer.

Quickly Leonardo grabbed his closest notebook, turned to a page with some space on one side, and scribbled down the recipe. *Linseed oil, I thought that was one of the primary ingredients,* he mused. *I will need to find the highest quality for this project.*

Satisfied he closed both books and sat back. Maybe he would actually begin painting the wall soon. He had been well aware of the growing number of other artists who had already begun to come to the Great Hall to watch the work there unfold. Even before either he or Michelangelo had put one speck of paint on the wall, others were there watching, whispering, and waiting. Once the actual painting began, who knew what type of a circus the area would turn into.

The time had finally come for Leonardo to actually paint the wall. He had been generally happy with the way the sketch of the middle section had gone from his notebook to the cartoon to the wall. He was satisfied that it showed the terror of war as he had desired.

Salai, Tommaso, and the various apprentices had carefully prepared his recipe for the paint colors and he had inspected each batch. They had carefully mixed the pigments with hot wax as he had instructed them.

Once again he was feeling pressured to get the work done, pressure that he wasn't planning to bend to. It had taken him time to get to this point, and it would take more time for the wall to actually be painted. Machiavelli and the city fathers would have to wait on the final result, whether it made them happy or not.

Leonardo gave his instructions to the carpenters the City Fathers had put at his disposal. He wanted his scaffolding built according to very specific instructions. He also purchased more paper for his second cartoon.

A week later, Leonardo climbed his carefully built scaffolding, and slowly approached the wall with his brush. Overall, he had fond memories of the painting portion of the *Last Supper* and he had to admit that he was excited about this project as well. The scale of the project might be overwhelming for some painters, but he knew that as long as he was allowed to go at his own speed, the enormous wall in front of him would cause him no concern. He would start slowly and carefully and work his way out from the middle. As he approached the bottom portions of his section, he was inclined to let Salai and his apprentices do some of the smaller sections. But he would have to get to that section first. Up here on the scaffolding it would just be him and his artwork.

Week by week he applied the vibrant colors to the wall. He tried not to pay attention to the growing number of on-lookers who came to watch his progress. As long as they stayed out of his way, he had decided he would not have them thrown out. Each day that he chose to paint, he came in, stirred the day's color carefully and started slowly painting.

Chapter Thirty-Three
Mona Lisa - Florence

1506

As Leonardo put the finishing touches on the two portraits of Madam Lisa he eyed them critically. Even though he had been hard at work of them for almost two years, he still felt like they were a work in progress. But he had started to hear the first grumblings from Lisa's husband about how long the project was taking and knew that he would be pressing the matter too much if he pushed for more time.

Leonardo studied both portraits, enjoying both the similarities and the differences. He had allowed Salai to work a bit on one of them, but had kept the other for himself to finish. Setting his own copy aside, he took another hard look at the one they had both worked on. Yes, it was still quite beautiful. He was certain that Master Giocondo would be pleased.

Checking carefully to see if the paint had dried on both of them, Leonardo carefully wrapped the one portrait and set it off to the side of his studio. He would work on it some more in the future, but for now it was time to start bringing projects at least to a temporary closure. His work on the Arno River canals had not ended as he had hoped, but it was finished. Now he would have Lisa's portrait delivered to Master Giocondo and receive his final payment. Then he would turn his focus completely to the battle painting, in hopes of finishing enough of it to please

the ever anxious City Fathers. But for now, it was time for a small celebration.

"Salai, please come here," Leonardo called.

Before he could call again, Salai and Tommaso were rushing into the studio.

"Yes, Master?" Salai responded.

"I have a couple of errands for you to run. Since Tommaso is here, you may both go. First, carefully wrap our finished portrait of Madam Lisa. Her husband is waiting for you to bring it to his office. Do you remember where that is?"

Salai nodded and Leonardo continued, "He will give you our final payment when you deliver the painting. Please deliver half of the money to our banker, and then I would like you to do some shopping with the rest of the money. Can you two handle that without getting lost or losing my money?"

They both nodded seriously and Leonardo handed a list to Tommaso and the wrapped painting to Salai. "Since you assisted me with portions of this painting, Salai, you may carry it. But, remember, it isn't necessary for Master Giocondo to know that you helped me. Patrons generally pay better without that knowledge."

Salai smiled knowingly as he carefully took the painting from his master. It had been exciting to be a part of this process, but he was willing to keep it their little secret. He and Tommaso rushed out of the door, excited to be heading back out into the streets.

<center>***</center>

Less than an hour later Salai and Tommaso stood in front of the master's banker, holding the ducats that they had not deposited. Salai was excited that Leonardo was finally entrusting him with more responsibilities. He had officially been the head assistant for longer than he could

remember, but often didn't feel like Leonardo treated him that way. But today he was enjoying every part of it.

Tommaso handed Salai the list he had been carrying and they studied it carefully. Leonardo was clearly planning to do some celebrating. They needed to pick up meat, eggs, mushrooms, salad, mulberries, and wine. Just reading the list made Salai's mouth water. Clearly Leonardo was enjoying having some money again, and they would all enjoy the benefits from it.

Chapter Thirty-Four
Battle Painting - Florence

1506

With the Arno River Projects a thing of the past, and his portraits of Lisa delivered or put away, Leonardo was ready to get back to work on the Battle Painting.

He surprised the City Fathers by showing up at the Great Hall day after day for more than two weeks. Slowly the intensity of the fighting in the middle of the wall had truly come to life in living color.

Leonardo climbed to the top of his scaffolding one day and then worked on a middle section the next day. As the painted portions came closer to the floor he turned more and more of those small sections over to Salai and his other apprentices.

And then the process began again. Top, middle, bottom. Repeat. The crowds watching him paint seemed to grow every day. And with Michelangelo back in Rome, interest in his wall had slowly died. All eyes, it seemed, were on Master Leonardo.

After several weeks of painting, Leonardo began to realize that the paint didn't seem to be drying properly. Even the first sections of the wall he had painted were still sticky when he carefully touched them.

After considering the problem, Leonardo instructed Salai, Tommaso, and the others to carry in several large pots of oil. Carefully he positioned the pots near the painted sections of the wall, and attached a series of ropes to each one, so that they could be moved up and down.

After testing his rope pulleys and demonstrating what he wanted done, he assigned two of his helpers to each pot. Carefully he lit each pot and instructed the groups to slowly pull them up and down in front of the painted sections of wall. Standing back he watched anxiously as the pots moved up and down. He was pleased that they were handling the pots slowly and carefully as he had instructed. It appeared that the heat was indeed drying the paint.

Suddenly there was a murmur of shock spreading throughout the room of onlookers. Leonardo looked on in horror as the paint in the middle section began to run slowly down the wall, soon completely covering the masterpiece he had been working on for so long.

"Stop!" he shouted at Salai and the others. Salai and Tommaso struggled to put down their pot of oil without spilling either fire or oil over the side. Leonardo stormed over to each pot, covering them each with the cover he had positioned nearby. After confirming that the fire in each had gone out, he turned and stormed out of the room.

Salai and Tommaso looked at the color dripping down the wall, looked at each other, and then rushed towards the door their master had just exited through. Salai looked at Tommaso, who seemed too shocked to speak. "I'm not sure whether we should try to follow him or stay here and see if we can do anything."

Tommaso looked back over his shoulder and shook his head. "Salai, there is nothing we can do. His hard work is all ruined, completely ruined. The Master didn't want to do this assignment in the first place. After all this, I don't believe he will ever return to his painting."

Salai nodded, slowly and sadly. This painting had indeed ended very badly.

Author's Note
Madison, Alabama
January 2017

In my reading and writing experience, historical fiction should have a strong emphasis on the **historical** portion.

As a result, I use as many accurate, historical details as I can when I write my historical novels – the description of the architecture and ruins that Leonardo would have encountered are as accurate as I can make them, though many times I have to use my imagination there too. It is easy to understand what the Pantheon and the Colosseum looked like when they were first built, and to see what they look like now, but to get accurate accounts of what shape they were in 500 years ago is a little more difficult. So I do my research and fill in the gaps as best I can.

This is a work of fiction – most of the conversations are from my own imagination, with one notable exception – the conversation between Michelangelo and Leonardo about Dante. The basics of that conversation have been handed down in a variety of places for more than 450 years.

The majority of the characters here are not fiction (Salai's sidekick Tommaso being the primary exception to that, but more on him in a bit.) And the major events depicted here are all based in history – between 1503 and 1506 Leonardo was leaving the employ of Cesare Borgia, trying to divert the Arno River and working on the massive

battle painting. And he was most likely working on the *Mona Lisa* during that time as well.

Leonardo experts don't all agree on the timing of his painting of the *Mona Lisa*, but I do believe he would have done most of the work on it during this time period, if for no other reason than that Raphael painted at least two paintings soon after that that were clearly based on the *Mona Lisa*, difficult to do if Leonardo didn't even start the painting for another ten years! I did use some creative license in the idea that there were two paintings being done at the same time, but I'm not the first person to suggest that. I have found no evidence that Leonardo would have given the second painting to the family, but I think it is plausible – and that's the only real requirement in filling in the gaps of historical fiction. The conversations between Lisa and Leonardo, her happiness as a mother, and the rest of those types of details are all from my imagination – but again, I think they all fit in the category of "how it might have been," so I think their inclusion is reasonable.

As I mentioned, with the exception of Tommaso, all of the other main characters in the book are historical figures. In the last novel, when Leonardo was going off to work for Borgia I needed to include a second servant figure, since historical records indicate Leonardo did have multiple servants with him during that time. I chose the name Tommaso since it seemed like a good, historic name from that region. And I made up his character completely from thin air. We know quite a bit about Salai since he had been with the Master for more than a decade at that time, and he was written about often by Leonardo and other contemporaries. But Tommaso was merely a figure of my imagination. It was only much later that I learned that Leonardo had indeed employed at least one young man

by that name. But I make no claims that my Tommaso bears any resemblance to the historic one!

Leonardo was definitely working for Borgia at the beginning of 1503 and certainly back in Florence sometime before mid-March of that year. He may or may not have traveled to Rome with Borgia before returning home – my research was not conclusive in that area. My initial research led me to believe that the younger Borgia had gone straight to Rome to see his father from his latest conquests in the Romagna area of Italy, but later research indicated that he may stopped several times along the way to cause more trouble. I liked the way the first version fit into my story, so I kept it.

We do know that Borgia was in Rome before Carnival ended that year (and that Venice and Rome had reputations for celebrating Carnival in some pretty outlandish ways in those days). We also know that Donato Bramante had been in Rome for several years at this point. In early 1503 he is not yet working on rebuilding St. Peter's, though by the end of the year, when a new pope has been installed, it is one of his first assignments. But by then Leonardo is back in Florence, hard at work on his several other tasks, so any connection between Leonardo and St. Peter's is a story for another time.

Leonardo and Bramante had worked almost side by side for many years in Milan and were indeed good friends. Machiavelli and Leonardo had worked together for some amount of time for Borgia, and did work together in Florence after that. My sources did not agree on how Leonardo had come to work for Borgia – he may have volunteered, Machiavelli may have suggested it, or Borgia may have asked for him. At least one of my sources concluded that Borgia and Leonardo actually met for the first time when Borgia came to Milan in 1499 with the French invading troops. I certainly believe Leonardo would

have seen Borgia there (he would have been hard to miss), but I haven't seen any conclusive evidence that they actually met before Leonardo went to work for him in 1502.

Michelangelo and Leonardo on the other hand were not good friends. Again it is not clear when they would have first met each other, but if not before 1503, they certainly would have met then. Leonardo was on the committee of artists who were asked to determine where Michelangelo's *David* sculpture would be located once it was complete. Michelangelo does seem to have considered Leonardo a washed up old man, and there is evidence that Leonardo considered Michelangelo a mere upstart. I haven't seen evidence that they actually interacted with each other directly, other than the brief, angry conversation about Dante and Leonardo's failed horse sculpture.

I had always understood that Leonardo and Michelangelo were painting on opposite walls in the Great Hall, but two of my recent sources (Jonathan Jones' book, *The Lost Battles*, and the related lecture in the Great Courses series on *Leonardo da Vinci and the Italian High Renaissance* by Professor Bent) suggested that they were actually on opposite ends of the same very long wall. I struggled with which way made the most sense to me, and then which way I wanted to portray it in the story. (You just read what I decided on.)

It is also true that both Leonardo and Michelangelo would leave their works unfinished — Michelangelo was called back to Rome to work for a Pope at some point while he was in the middle of his battle painting, and Leonardo did indeed run into some technological problems that seemed to bring the end of his work there. There seems to be different theories on how far both of them had gotten, when they each stopped, and what happened to their paintings when they walked away.

Another small note, for accuracy's sake: I have Tommaso and Salai counting and enjoying Leonardo's books in 1503 because that's where I wanted to fit it into the story. But Leonardo's list of 116 books is actually from 1504, so it's possible some of the books mentioned here weren't in his collection yet in 1503 – but it's doubtful we will ever know one way or another – or that most of you care about that little tidbit!

And one final historical note, for the sake of full disclosure. I've tried to keep the various chapters in chronological order as much as possible, and the dates as accurate as possible. But in many cases, the exact timing of these events, from the work on the Arno River to the different stages of the battle paintings or his work on the *Mona Lisa* are not known precisely. So some of these may be slightly out of order. But everything here more or less took place between 1503 and 1506.

"Art is never finished, only abandoned."

Leonardo da Vinci

About the Author

With more than a passing interest in Leonardo da Vinci, Catherine has been researching, teaching, and writing about him for more than a decade. Her first work on him was a short, but fairly complete biography, *Da Vinci: His Life and His Legacy. Leonardo the Florentine* was her first novel, starting the series, *The Life and Travels of Da Vinci*. The next books in the series are *Leonardo: Masterpieces in Milan, Leonardo: To Mantua and Beyond,* and *Leonardo: A Return to Florence*. She is excited to finally be releasing book five, *Leonardo: A Return to Painting*.

Catherine's books are available as paperbacks, e-books (and a growing number of audio books) and can be found on Amazon and other major book distributors.

More information on Catherine's other books can be found on her author's page on Amazon or on her websites:

www.CatherineJaime.com

www.CreativeLearningConnection.com

A review on Amazon about your experience with this book is greatly appreciated.

95710782R00093

Made in the USA
Columbia, SC
15 May 2018